GIORGIO
MORANDI

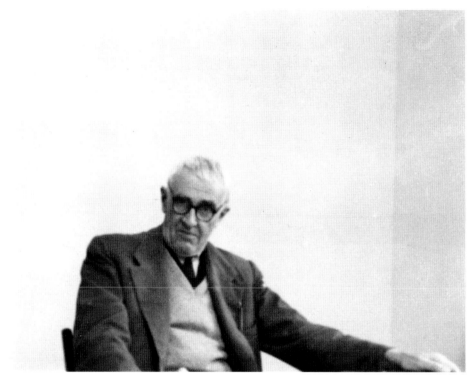

Giorgio Morandi, c. 1961. Photo © Stephen Haller.

GIORGIO MORANDI

KAREN WILKIN

RIZZOLI
NEW YORK

Acknowledgments

Thanks are due to many for encouraging and furthering this project: to Hilton Kramer, editor, *The New Criterion,* and Graham Nickson, director, The New York Studio School, for giving me the opportunity to develop the preliminary ideas in this book; to Dottoressa Marilena Pasquali, director, Museo Morandi, Bologna, and Lorenza Selleri of her staff, for their generous cooperation and assistance; to Sidney Tillim, Leopold Plotek, Paolo Baldacci, director, Paolo Baldacci Gallery, and Stephen Haller, director, Stephen Haller Gallery, for invaluable information; to William E. O'Reilly, W.S. Di Piero, Daniel Solomon, Cylla von Tiedemann, Sheila Samton, Joshua Samton, and Donald Clinton, for many different reasons known to each of them; and to Juan de Muga for his patience and support.

First published in the United States of America in 1997 by

RIZZOLI INTERNATIONAL PUBLICATIONS, INC.
300 Park Avenue South, New York, NY 10010

© *1997 Ediciones Polígrafa, S.A.*
Reproduction rights:
© Giorgio Morandi. VEGAP, Barcelona, 1997
Text copyright © Karen Wilkin
Designed by Jordi Herrero

LC 92-72888
ISBN 0-8478-1947-7

Color separations by Leicrom (Barcelona)
Printed by Filabo, S.A.
Sant Joan Despí (Barcelona)
Dep. Leg. B. 44.996-1997 (Printed in Spain)

Contents

Giorgio Morandi by Karen Wilkin

I

Giorgio Morandi's works are embodiments of paradox, at once forthright and elusive, straightforward and subtle, intuitive and cerebral. They are multivalent, enigmatic pictures that can be read with equal accuracy as highly distilled, specific images of a private, but recognizable world—and as universal, non-specific abstractions. Curiously, these deceptively modest paintings, drawings, and prints seem to elicit only two responses: extreme enthusiasm or near-indifference. And yet, this is not surprising, since Morandi's art makes no effort to be ingratiating or to put itself forward in any way. Quite the opposite. Restrained, rather severe, and not overtly sensuous, it demands that viewers exert themselves if they are to discover its true character. But for enthusiasts, these small, reticent still lifes and austere landscapes are enormously rewarding. For anyone who pays attention, the microcosm of Morandi's tabletop world becomes vast, the space between objects immense, pregnant, and expressive; the cool geometry and greyed tonalities of his outdoor world become intensely evocative of place, season, and even time of day. The austere gives way to the seductive. Those impervious to Morandi's excellences often dismiss him as boring. It is significant, however, that many of Morandi's most passionate admirers are his fellow artists. For once the cliché "a painter's painter" is apt, so much so that it is sometimes tempting to use a response to Morandi's work as a partial measure—among artists and non-artists alike—of the ability to see, or at least of the ability to perceive issues fundamental to painting.

Similar paradoxes exist in the way Morandi has been viewed throughout his long career and even since his death in 1964. It is not an exaggeration to describe him, as Degas has been described, as one of "the most misunderstood of famous modern artists."[1] Just as Degas, one of the most complex and inventive of nineteenth-century painters and sculptors, is often categorized merely as 'the Impressionist who painted ballet dancers', Morandi has been identified with a similar lack of penetration, as 'that Italian painter of bottles lined up in a row'. Misunderstood or not, Morandi is famous, even revered in some circles, and has been for a long time. He was acclaimed in his native Italy beginning remarkably early in his career,

1.

Boy, 1907.
Graphite on cardboard,
21 ¹/₄×16 in. (54×40.5 cm).

2.

Landscape, 1911.
Oil on canvas,
14 ³/₄×20 ¹/₂ in. (37.5×52 cm).

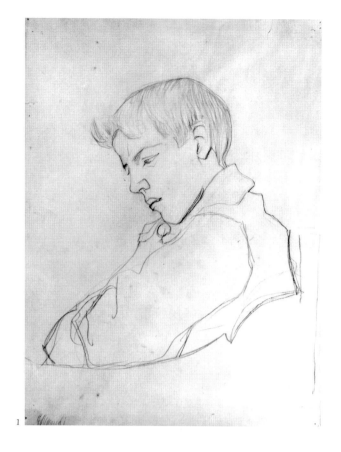

1

2

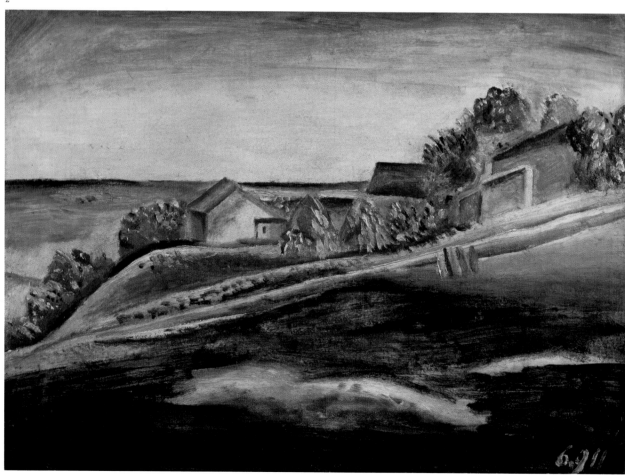

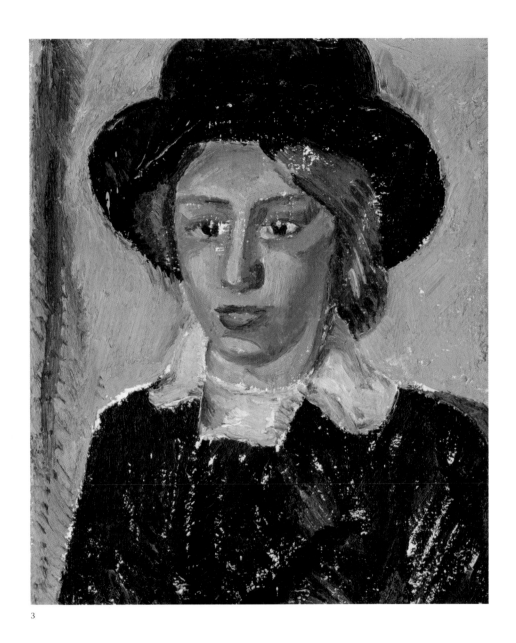

3

3.
Female Portrait, 1912.
Oil on canvas,
17 1/2 × 14 1/2 in. (44.3 × 37 cm).

and became, over the years, a kind of national treasure—the grand old man of modern Italian art, represented in the most significant public and private collections. In North and South America he is viewed more dispassionately, and his work is collected less assiduously, yet he is taken just as seriously as in Europe. Major works by Morandi figure in prestigious North and South American collections, both public and private. On the whole, though, the artist has been less celebrated in the New World than in the Old; his name is generally less familiar, and American museums that own important works by Morandi don't always exhibit them with any regularity.

Morandi's reputation seems secure, his preeminent place in the history of recent art—especially recent Italian art—seems assured, yet there has been remarkably little consensus in the interpretation of his work over the years. He is viewed variously as a cult figure, a national institution, a voice of radical modernity, a guardian of traditional values, a timeless paragon, and a period piece. There are even some who dismiss him as a minor figure. Morandi's work was conspicuously absent, for example, from a survey of post-war Italian culture at New York's Guggenheim Museum in 1994, an otherwise comprehensive and ambitious exhibition that purported to examine the full spectrum of creativity in Italy between 1943 and 1968—a period that includes the years of Morandi's greatest power and inventiveness.

It is also curious that despite Morandi's considerable reputation, until quite recently it has been difficult, apart from the occasional special exhibition, to see his work in any depth. Much of Morandi's best work has remained in private hands, with a surprising number of outstanding pieces divided among a few devoted friends and collectors who had grown close to the painter during his lifetime. It is still difficult to see Morandi's work in coherent groupings in North America, but in Italy a fine range of examples is now far more accessible, as lovingly guarded private collections enter the public domain, often as the bequests of that original handful of loyal collectors. Among them are men of letters, connoisseurs, and critics who, like Morandi himself, helped to define our conception of Italian modernism. The most notable of these recently available public collections is the exquisitely installed Morandi Museum in the painter's native Bologna, which opened to visitors in the fall of 1993. It is a superb, if slightly idiosyncratic collection of paintings, drawings, watercolors, graphics, and memorabilia, including a small but telling group of works collected by the artist, all given to the municipality by the artist's sisters.

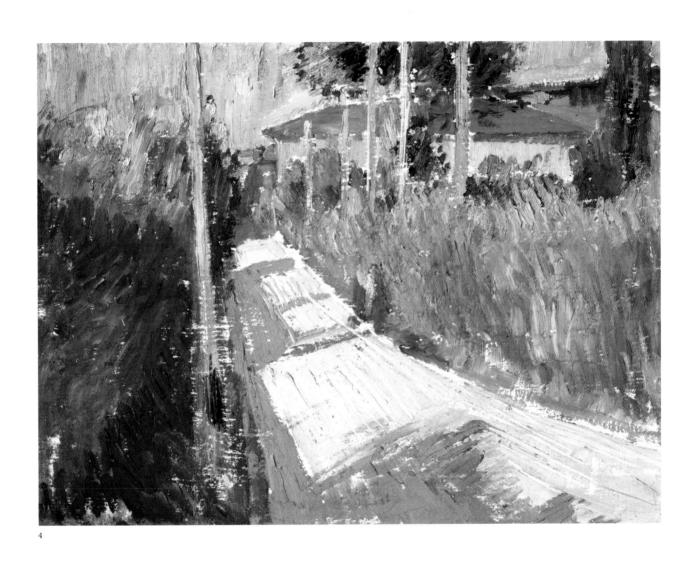

4

4.

Landscape, 1913.
Oil on cardboard,
16 1/8 × 20 in. (41 × 51 cm).

5

6

5.

Landscape, 1913.
Ink on paper,
7 1/8×7 1/2 in. (18×19 cm).

6.

Composition, 1914.
Ink on paper,
9 1/2×8 5/8 in. (24×22 cm).

12

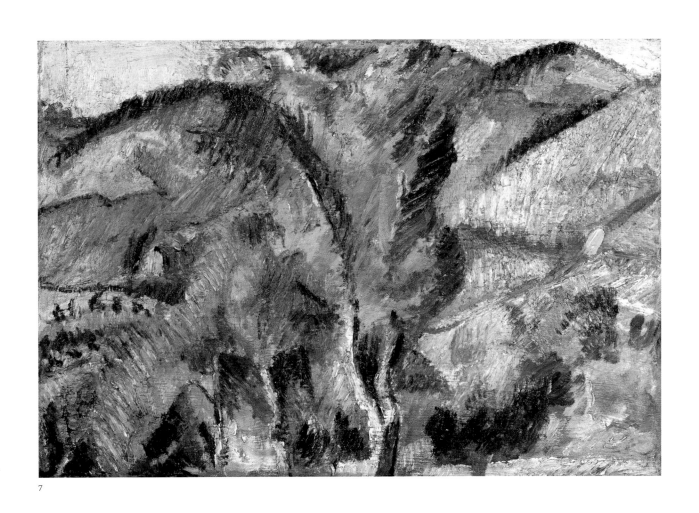

7

Landscape, 1913.
Oil on canvas,
17 $1/2 \times 26$ in. (44.5×66 cm).

Such accessible groupings of the work of this modern master are invaluable, even though those who are indifferent to Morandi will maintain that his chosen territory is so narrow that to have seen one or a few pictures is to have seen them all. But it is precisely *because* his field of inquiry is so circumscribed—still lifes that focus on a collection of unremarkable objects, and landscapes that pit generic Italian trees against generic Italian houses— that seeing Morandi's art in some quantity is essential to an understanding of his achievement. The expressiveness that he could extract from nuance, the variety he could wrest from adjustments of scale, and the poetry he could find in apparently minute changes, are most apparent when you can compare groups of pictures, just as the full complexity of Morandi's palette is most readily perceived when several paintings are seen together. This is especially evident when the works in question are closely related. Then, the breadth of his inventiveness as a manipulator of color and tone becomes more visible than the deliberate restrictions he placed on himself, and his ability to evoke infinite qualities of light, times of day, and shifts of mood by setting exquisitely adjusted, muted, nameless hues side by side becomes overwhelming. More Morandi, it turns out, is more.

It is particularly important to be able to return to the evidence of the works themselves because today, more than a quarter century after his death, the myth of Morandi risks being better known than the fact of his art. The legend of the shy, unworldly painter, humble to the point of being self-effacing, indifferent to sales or reputation, dedicated to nothing but his work, is extremely appealing, especially in today's climate of cynical careerism and commercialism. The recollections of those who knew Morandi, both close friends and acquaintances, however, suggest a more cheerful, capable individual than the withdrawn, introspective recluse demanded by the myth. He enjoyed salacious rhymes and surprised an American painter who visited him about 1960 by his "gentle garrulousness." This visitor declared the supposedly reclusive, unassuming Morandi to be "an impressive man," and noted that part of his presence was a "quality of *accessibility*. He was neither a charismatic personality nor did he seem conscious of himself."[2] Yet many of the same recollections reinforce the legend of the self-contained, modest Morandi, and present us with a portrait of a notably formal, rather old-fashioned individual who used the familiar *"tu"* only with his family and a very few friends from his youth.

Mythologized stories about Morandi abound: about his quasi-monastic way of life, his devotion to his family and to his native city, the apartment

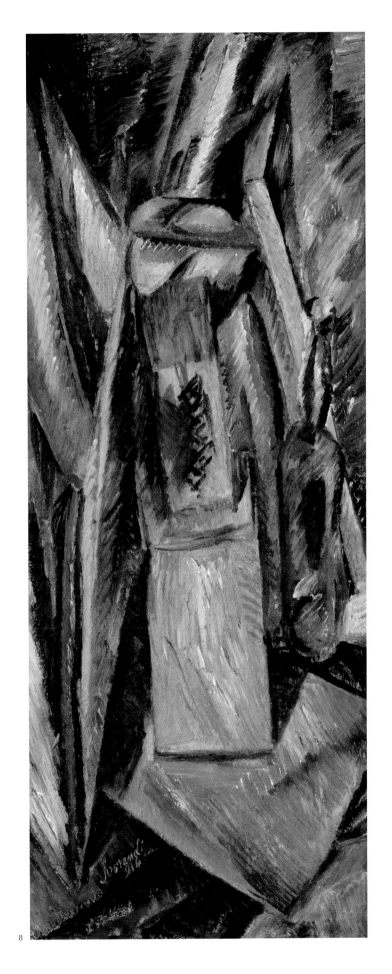

8

8.
Still Life, 1914.
Oil on canvas,
40 1/8 × 15 3/4 in. (102 × 40 cm).

15

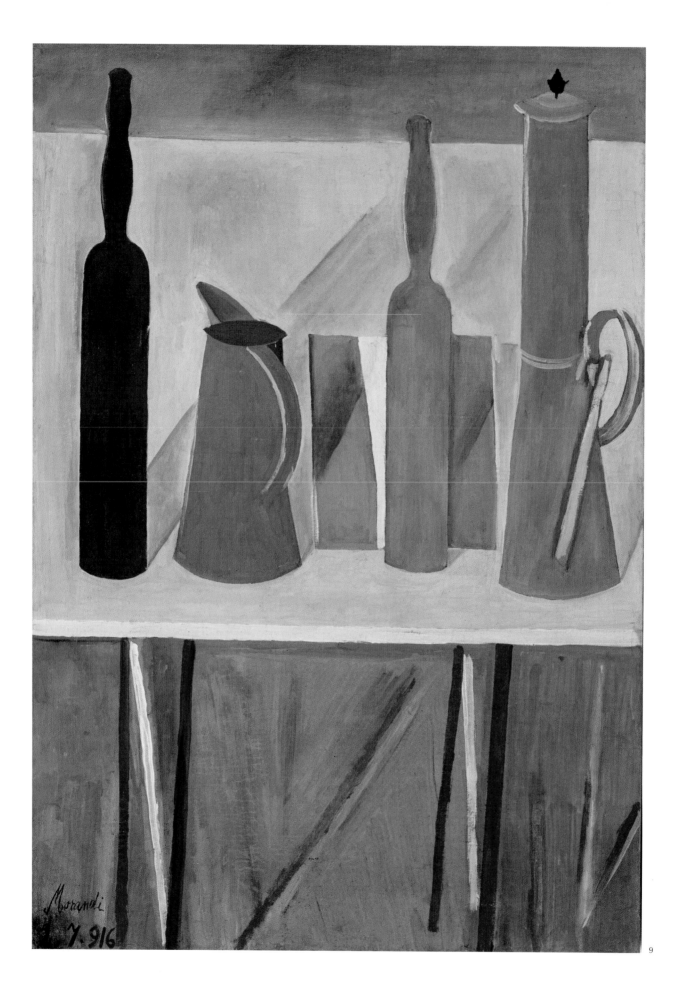

10

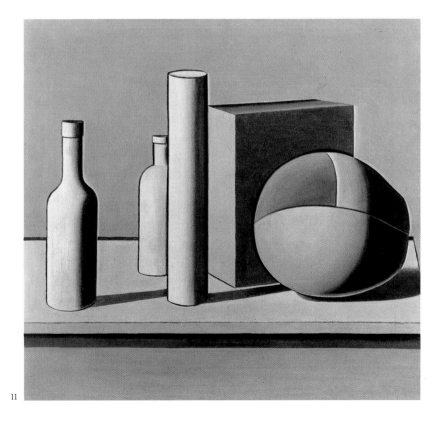

11

9.
Still Life, 1916.
Oil on canvas,
32 1/2 × 22 5/8 in. (82.5×57.5 cm).

10.
Still Life, 1918.
Oil on canvas,
26×22 in. (65×55 cm).

11.
Still Life, 1919.
Oil on canvas,
20 1/4 × 21 5/8 in. (51.5×55 cm).

he shared for his entire life with his three unmarried sisters, his cluttered but spartan studio, the thick "unifying layer" of dust on the objects that served as still life models, the volume of Giacomo Leopardi's poems that never left his bedside, and his long service as a professor at the Bologna Academy of Fine Arts. They are stories of a quiet, ordered, uneventful life—as quiet, ordered, and uneventful, some might say, as Morandi's paintings.

But just as many of us find drama and tension in those hushed, self-contained pictures, there are also moments of drama to be found within the Morandi myth. There was the shock, for example, of the renowned Roberto Longhi's address in 1934 upon assuming the chair of art history at the University of Bologna, in which he traced the long and distinguished history of Bolognese painting, ending with Giorgio Morandi, "one of the best painters living." Longhi's audience reacted to the pronouncement that the local professor of etching was the heir to the great tradition of the Carracci and Guido Reni with stupefaction; "murmurs of protest and surprise" were reported by many witnesses.[3] At the time, Longhi was one of the most eminent scholars in Italy and widely respected internationally, so his praise counted as more than mere "official" academic recognition. Like his colleagues and contemporaries Bernard Berenson and Irwin Panofsky, Longhi had a reputation not only as a historian and theorist, but as a connoisseur with a penetrating eye. Unlike the rest of the celebrated art historians of his generation, however, Longhi had close friends among his artist contemporaries, which may help to explain his willingness to accord art of his own time the same serious attention that he gave to art of the past. As art historical anecdotes go, the story of Longhi's address to the university is pretty tame, with none of the high drama of the life of Van Gogh or Gauguin, or the tabloid sensationalism of the legend of Picasso or Warhol, but it must nonetheless have been an extraordinary moment for Morandi, then an established artist of forty-four with a respectable but unspectacular "domestic" reputation.

The myth of Morandi is not only attractive, but like most myths, it is ultimately grounded in truth. Yet, as time passes, and the living artist becomes more remote from us, as the myth becomes the standard reference, it is more important than ever to refer to the art and not to the legend. The number of Morandi's works that have been added to the public domain in recent years should help make this possible. Ironically, though, Morandi's increased visibility has somewhat compounded the problem of his true identity. As Morandi's reputation has grown, so has the Morandi

12.
Still Life, 1920.
Pencil on paper,
$7^7/_8 \times 10^7/_8$ in. (20 × 27.5 cm).

13.
Still Life, 1920.
Oil on canvas,
$19^1/_2 \times 20^1/_2$ in. (49.5 × 52 cm).

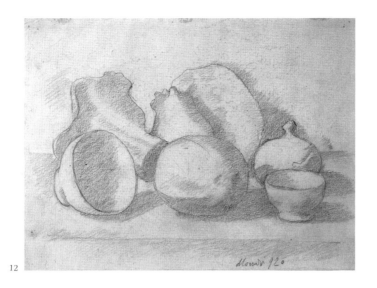

12

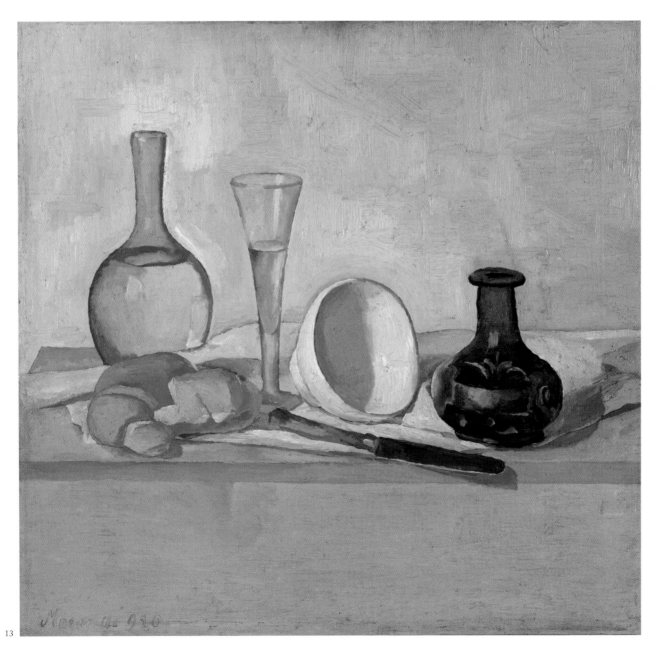

13

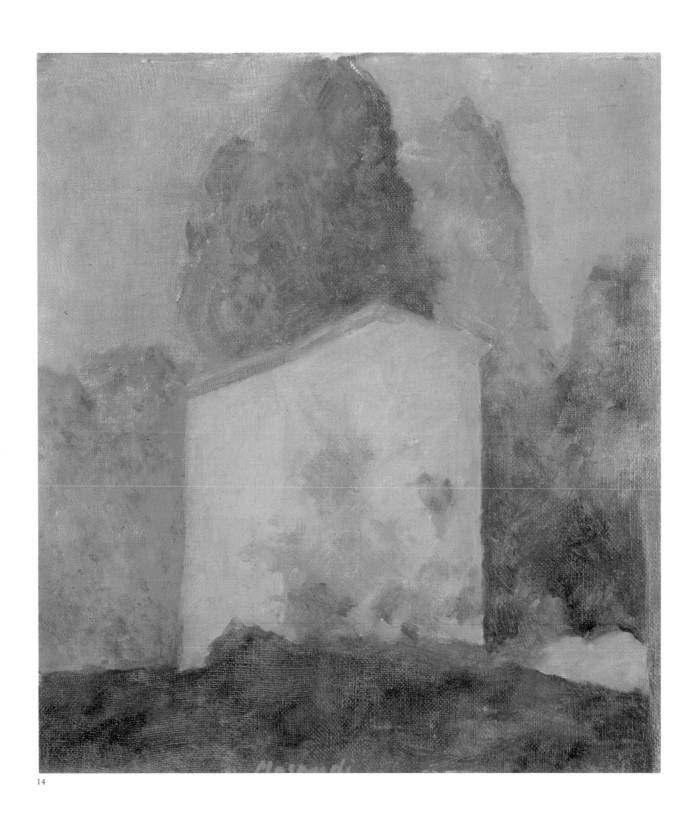

14

14.

Landscape, 1921.
Oil on canvas,
13×11 ½ in. (33×29 cm).

literature—a massive body of critical discussion, memoirs, and formal and informal writing that has gradually accumulated around the artist's *œuvre*. Much of it is extremely interesting and informative; some of it is even illuminating, and enriches our perceptions of this enigmatic artist. But as previously noted, perhaps most striking is the sheer diversity of the opinions and points of view generated by Morandi's work over the years. It is fascinating to see how he has been claimed now by this faction, now by that, his work co-opted by a range of apparently opposing camps, each equally admiring.

Morandi's work has been praised both for its inherent Italianness and for its universality; the artist has been applauded both for standing firm against an onslaught of fashionable new-fangledness, and for rapidly becoming aware of a modernist aesthetic and assimilating its principles. Particularly during the 1920s and 1930s, most of the critics who wrote about Morandi appropriated him for their own ends, presenting him as a conservative classicist, a nationalist revivalist, and a champion of traditional values in Italian art—someone who held out against the pernicious foreign influence of experimentation and intellectualism.[4] Leo Longanesi, for example, writing at the end of 1928, congratulated Morandi for not "turning somersaults on the Cubist-primitive trapeze,"[5] while in an article written in 1935, even the acute and sympathetic Longhi couched a discussion of the evolution of Morandi's work in terms of implicit praise for conservatism. Longhi approved of the painter's having "steered his course through the dangerous waters of modern painting with such thoughtful slowness and loving studiousness that he seems to be setting out in a new direction."[6] More recent commentators have tended to adopt quite different points of view, stressing Morandi's connections with modernism or his irreducible individuality. Some of the most current writings have taken neither one position nor the other, and instead have focused not so much on Morandi's art as on the changing perceptions provoked by that art, examining the accumulated written evidence of how the artist was regarded at different moments in his career.

It is perhaps significant that some of the most perceptive comments on Morandi's work are not written by critics or art historians, but rather by his fellow artists. The critic-turned-painter, Ardengo Soffici, writing in 1932, described his colleague's quest as an attempt to create "from the elements of visible reality, not an anecdotal depiction subject to the accidents of the moment and of placement, but an harmonious ensemble of colors, forms,

15.

Still Life, 1924.
Graphite on paper,
6 $\frac{1}{8}$ × 6 $\frac{7}{8}$ in. (15.5×17.5 cm).

16.

Still Life, 1926.
Oil on canvas,
23 $\frac{5}{8}$ × 23 $\frac{5}{8}$ in. (60×60 cm).

17.

Self-Portrait, 1925.
Oil on canvas,
24 $\frac{3}{4}$ × 19 $\frac{1}{8}$ in. (63×48.5 cm).

15

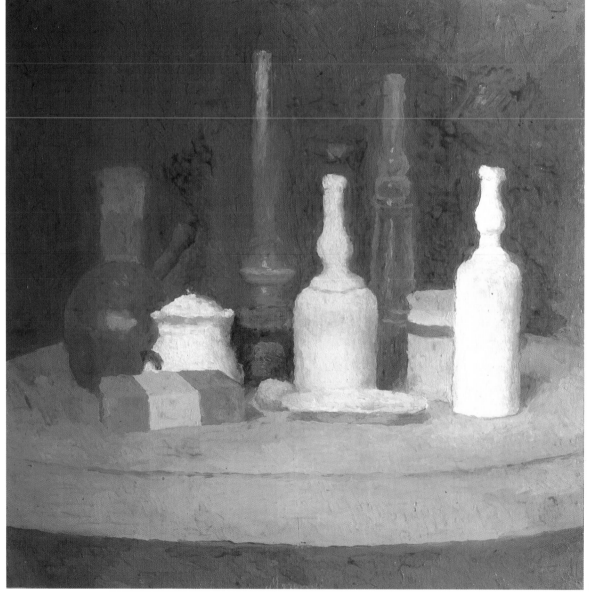

16

Still Life, 1924.

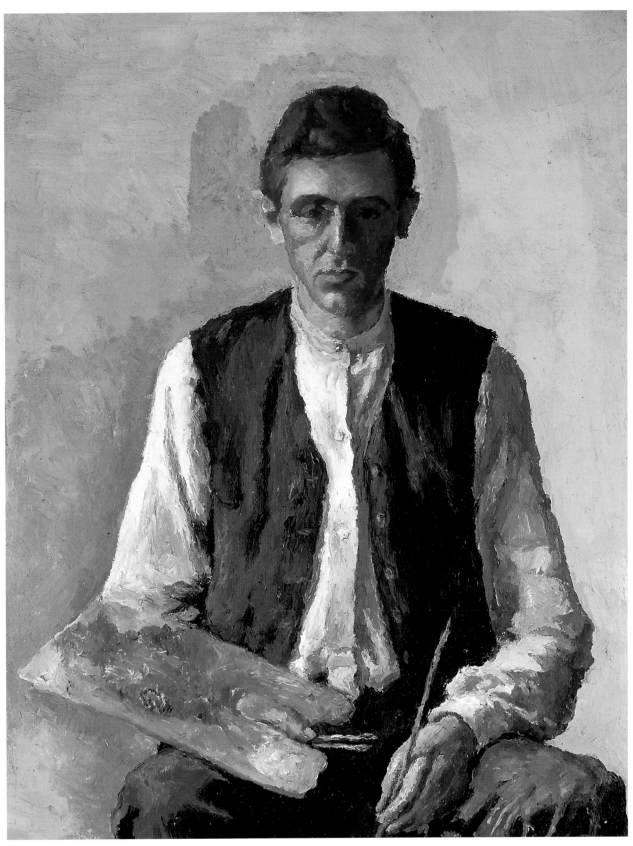

17

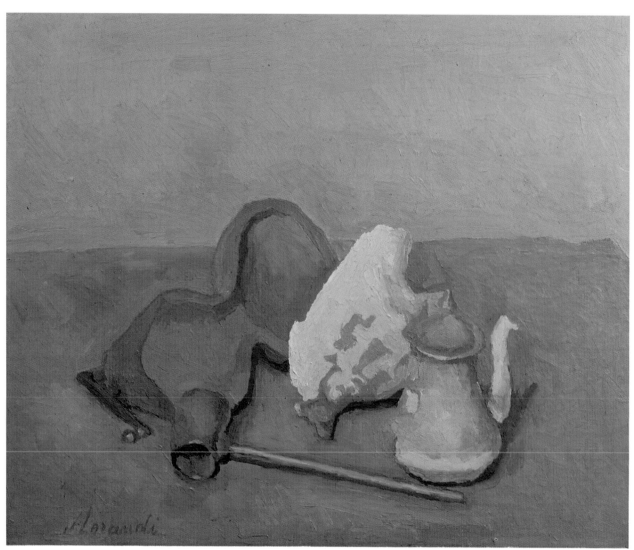

18

18.

Still Life, 1929.
Oil on canvas,
21 ¼ × 25 ¼ in. (54 × 64 cm).

volumes that obey only the laws of unity—like the beauty of chords." Morandi, Soffici believed, "has been working in a bold revolutionary manner to achieve this," through a process of increasing simplification and economy.[7] The observations of the American painter and critic, Sidney Tillim, are even more incisive: "Morandi was . . . suspended between the speculative and the decorative. He was both ahead of his time and behind it. If his landscapes are more successful as paintings, his still lifes are more radical in aspiration."[8]

Any effort to identify the formative influences and the crucial encounters in Morandi's working career—or any artist's, for that matter—obviously depends on careful research and meticulous study of the historical record, but the real evidence of how he responded to challenges and stimuli can be found primarily in his work itself. Only by looking closely at Morandi's art can we determine the truth or fallacy of the claims of his commentators. It seems obvious from his surviving drawings and canvases of the early 'teens, for example, that Morandi was not the unswerving Italian nationalist posited by some critics of the 1920s. He was not only well aware of some of the most progressive ideas about pictorial space and form being explored by French artists of the period, but clearly found these "foreign" notions to be useful and stimulating. Yet, when we look closely at Morandi's work, issues of politics and allegiances—other than aesthetic ones—become, if not largely irrelevant, of less than paramount significance. His art, while unmistakably born of the particular experience of an individual, is devoid of ideology or program. Or rather, if an ideology can be attributed to Morandi's work, it is simply a profound conviction that, through the most economical and rigorous means, art can move us deeply; that our entire being—emotions and intellect, intuition and reason—can be addressed through the eye. About 1959, Morandi declared this unequivocally, describing himself as "a believer in Art for Art's sake rather than in Art for the sake of religion, of social justice or of national glory. Nothing is more alien to me than an art that sets out to serve other purposes than those implied by the work of art in itself. . . ."[9]

II

The facts of Morandi's biography are straightforward, undramatic, and well known. Born in Bologna in 1890, he was the eldest of the two sons and three daughters of Andrea and Maria Maccaferri Morandi. (The younger son did not survive childhood.) His father, a respectable member of Bologna's middle class, worked in an export office, where the young Morandi was briefly employed in 1906. The following year, he abandoned commerce to enroll in the Bologna Academy of Fine Arts, from which he received his diploma in 1913. Few works have survived from those student years, but what remains—drawings, the earliest extant print, some already characteristic landscapes—suggests that the aspiring young artist found considerable room for experimentation, even within the strict discipline of academic training. During his student years and for more than a year after completing his course at the Academy, until he began to teach drawing and printmaking in the Bologna public schools in the fall of 1914, Morandi seems to have traveled in Italy a good deal. He studied first hand both celebrated monuments from the past and whatever works of art of the present were visible in international exhibitions such as the Venice *Biennale.* (This was, it turns out, a crucial period in his education as a painter; since he traveled less after the 1920s, these early direct encounters provided an important context for his continuing experience of photographs and reproductions in the art books he collected.) In 1915, following the outbreak of the First World War, Morandi was drafted into the army, but he was soon discharged because of poor health. Seriously ill during the next few years, he was sometimes forced to interrupt the time he spent making art, but he continued to teach in the Bologna schools, retaining his post until 1930 and serving, in addition, as Director of Primary Schools for four small districts in 1926–27. In 1930, however, Morandi was appointed professor of etching at the Bologna Academy of Fine Arts, where he remained until 1956, when the now internationally acclaimed artist finally dedicated himself to full-time painting and printmaking.

Very little altered the established rhythm of Morandi's life and work. After his early years of travel and eager study, he preferred not to

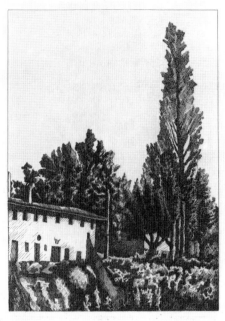
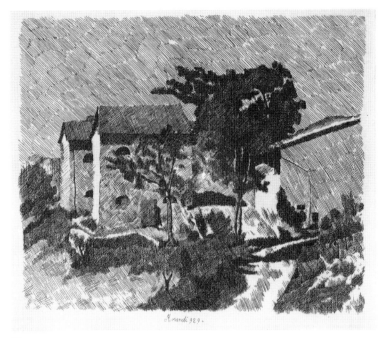

19 20

risk disrupting his work habits. "I can't go see too many exhibitions," he once told a friend. "It upsets me for two or three days."[10] Until his retirement from the Academy, Morandi's life was divided between teaching and working in his studio in Bologna, and when possible, in the summer in the nearby mountains. After his retirement, he continued to paint, as he had for decades, in the family apartment on the Via Fondazza that he shared with his three unmarried sisters (and with their mother until her death in 1950). He had chosen the room he worked in because of its light, rather than for its size or convenience; it was small—about nine square meters—and as visitors frequently noted, it could only be entered by passing through the bedroom of one of his sisters. Morandi was troubled when post-war construction in the neighborhood altered the quality of the illumination that had become both habitual and essential to his art, but he continued to work in the small, cluttered space to which he was so deeply accustomed, surrounded by the accumulation of humble objects—bottles, pitchers, *caffe latte* bowls, boxes, and the like—that served as models for his still lifes. During the summer months, he went to the mountains, chiefly to the nearby town of Grizzana, accompanied by at least one of his sisters.

Morandi may have arranged his life to insure that he could concentrate fully on his art, but he was unable to insulate himself completely from the upheavals and political turmoil of his times. During the 1930s, he found himself in opposition to the Fascist notions current at the Academy where

19.
Landscape with Large Poplar,
1927.
Etching on copper,
12 3/4 × 9 1/4 in. (32.4 × 23.5 cm).

20.
*The Three Campiario Houses
at Grizzana,* 1929.
Etching on zinc,
9 7/8 × 11 7/8 in. (25.1 × 30.1 cm).

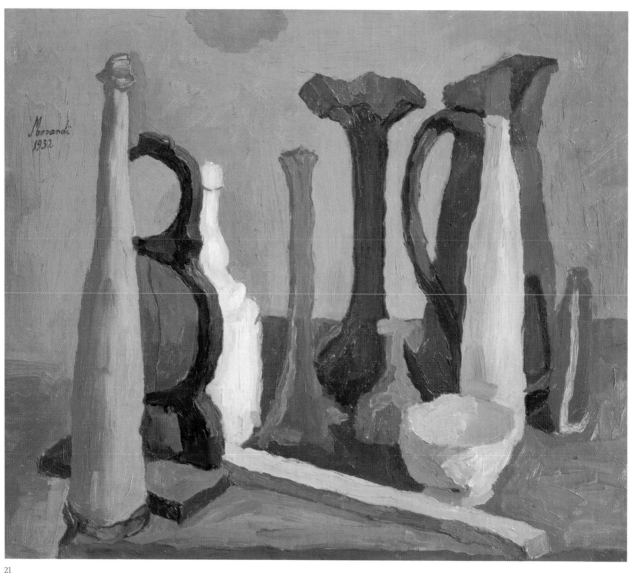

21

21.
Still Life, 1932.
Oil on canvas,
24 1/2 × 28 3/8 in. (62.2. × 72 cm).

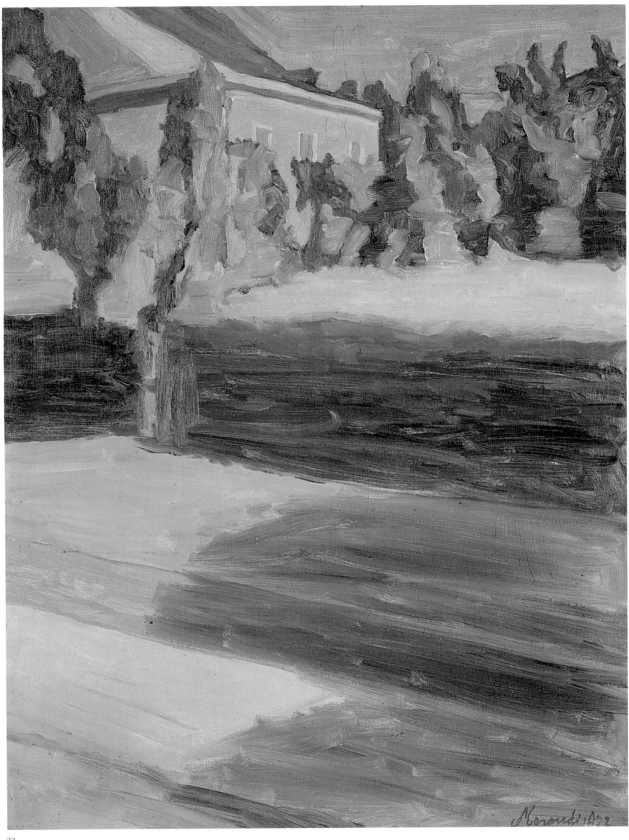

22

22.
Landscape, 1932.
Oil on canvas,
29 $^1/_2$ × 23 $^5/_8$ in. (75 × 60 cm).

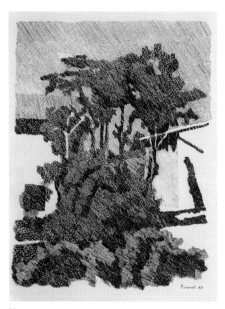

23

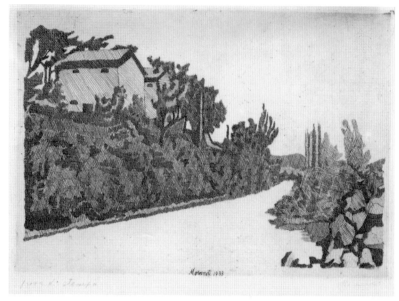

24

25

23.

*Trees among Houses at
Grizzana*, 1933.
Etching on copper,
8 5/8 × 6 1/2 in. (21.8 × 16.5 cm).

24.

The White Road, 1933.
Etching on copper,
8 1/4 × 12 in. (20.8 × 30.3 cm).

25.

*View of Montagnola from
Bologna*, 1932.
Etching on copper,
8 3/8 × 13 1/8 in. (21.2 × 33.2 cm).

he taught, although he managed to keep his job.[11] The issues were relative-
ly minor; fascist authorities, eager to have the highly respected artist pub-
licly associated with their cause, chastised him for keeping himself aloof in
what was perceived as an ivory tower, and reproached him for not com-
peting for official prizes.[12] Worse, however, was to come. In 1944, during the
Second World War, he was accused of being
a member of the resistance and was briefly
imprisoned. After the war, the steady
rhythm of his life resumed: an uninter-
rupted concentration on painting, etching,
and teaching, with regular sojourns to
Grizzana, where he and his sisters eventu-
ally built a modest house and studio. He
traveled little and permitted few interrup-
tions in his tranquil existence, despite his
growing fame—a fame that he found prob-
lematic, fearing that it would disturb his

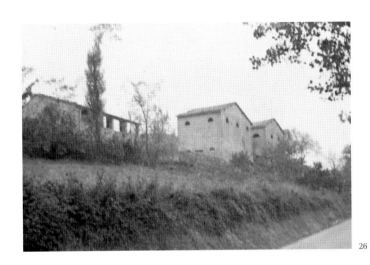

26

ordered life. In 1958, for example, he explained to a friend that he had
refused to participate in a fairly important international exhibition because
the organizers were too insistent. "They really want to deprive me of that
small measure of calm that is necessary for my work."[13] Morandi died in
Bologna in 1964, a month short of his seventy-fourth birthday, in the Via
Fondazza apartment where he had lived and worked for most of his life.[14]

26.
Near Grizzana.
Photo © Stephen Haller.

On the surface, this history is notable for its uneventfulness.
Morandi himself seems to have encouraged this view, describing himself
simply as someone from Bologna who taught etching, and who painted
and etched landscapes and still lifes. If pressed, he might list some of the
celebrated critics and men of letters who had written about him, without
mentioning that their comments were wholly enthusiastic and admiring.
That the simple professor of etching had been awarded his position on the
strength of his "evident renown,"[15] without having to go through the usual
application procedures, was the sort of information that he characteristi-
cally omitted mentioning. Yet, visitors to the studio, art historians, inter-
viewers, and the like, even at the end of Morandi's life, describe someone
"intellectually congenial," who was not only "willing to answer questions,"
but "did not have to be asked a question in order to venture a remark."[16]
One historian, a trained observer, suggested that Morandi even exercised
a subtle control over their interview.[17] At times, a rather puckish humor

27

27.

Landscape, 1934.
Oil on canvas,
24 × 21 ⁵⁄₈ in. (61 × 55 cm).

28

28.

Landscape, 1935.
Oil on canvas,
$23\,^5/_8 \times 28$ in. (60×71 cm).

broke through. The critic Giuseppe Raimondi quotes his friend describing a picture composed "of my usual things. You know them. They are always the same. Why should I change them? They work pretty well. Don't you think?"[18]

Morandi seems to have regarded the patterns of his daily life in the same way that he did his "usual things." Friends describe his disciplined days, his regular walks from the stubby arcades and warm ochre walls of Via Fondazza, along elegant streets and through sudden, bustling market squares, to the Academy at the edge of the university, and back again. The legend of Morandi was constructed while he was still alive, a not entirely inaccurate fable that seemed to suit his instinct for self-protection, so that the "official" details of his habitual existence—the now familiar particulars of the modest home at Via Fondazza, of what have been called "the three vestal sisters who protected his solitude," and what has been described as his "immutable rootedness in his city, in its streets and its most time-honored traditions"[19]—became a familiar litany substituting for more intimate biographical information.

Some of the most revealing glimpses into Morandi's history are to be found not in biographical anecdotes but in the list of exhibitions, honors, and distinctions he achieved because of his art, and in the names of the critics who wrote about him. These are records that admittedly tell us more about how the painter—or more accurately, his work—was perceived than it does about how he lived his life, but they nevertheless offer insight into his connections—with other artists, with writers, in short, with members of a community of intellectuals and creative people that included some of the most adventurous Italian artists of his day. The painter described even by his close friends as "shy" and "provincial" may have valued his privacy and his independence, but he was hardly isolated from the Italian vanguard. His education at the Academy may have been largely conventional, but it is evident, both from his surviving early works and from even the most skeletal account of his professional history, that he was, almost from the outset, receptive to unconventional notions of what art could be.

Morandi first showed his work in a now legendary 1914 exhibition at the Hotel Baglioni in Bologna, with Osvaldo Licini, among others. This exhibit led to Morandi's introduction to the Futurists, with whom he exhibited later that same year in Rome. By 1914 the Futurist movement was dissolving into conservative and radical factions. Morandi's connection with

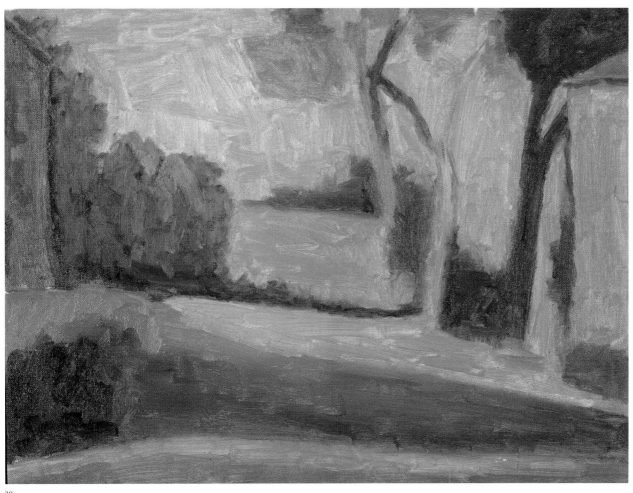

29

29.

Landscape, 1936.
Oil on canvas,
18 1/8 × 24 1/4 in. (46×61.5 cm).

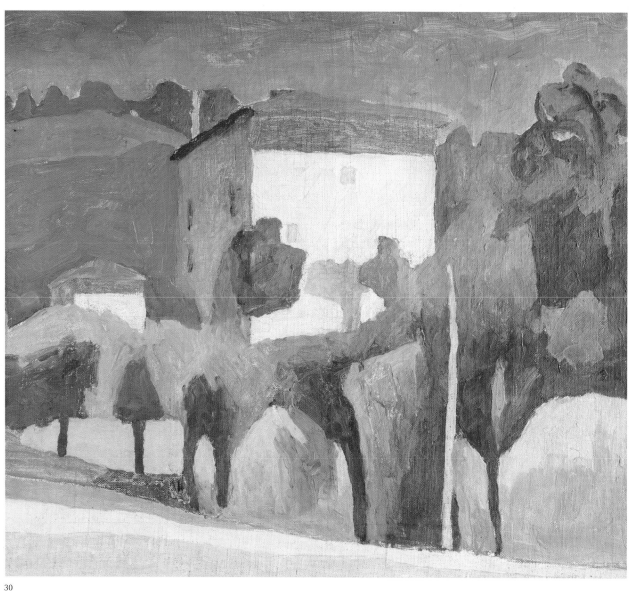

30

30.

Landscape, 1936.
Oil on canvas,
21 × 24 ¾ in. (53.5 × 63 cm).

36

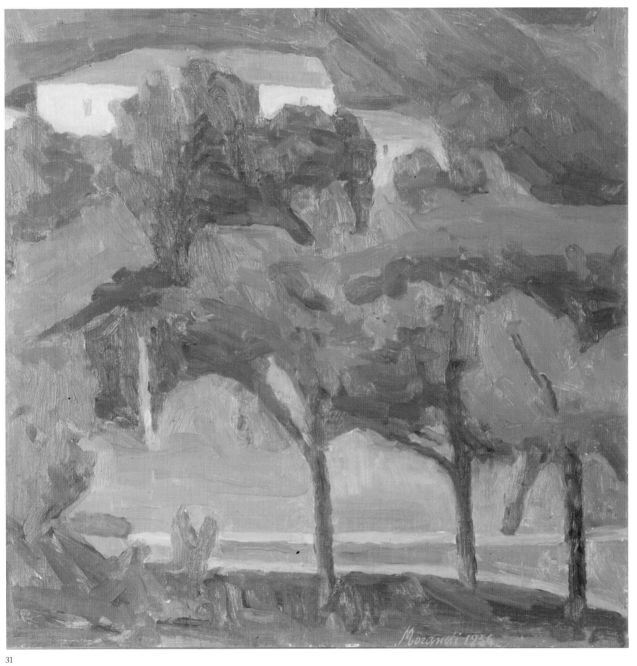

31

31.

Landscape, 1936.
Oil on canvas,
23 ⁵/₈ × 23 ⁵/₈ in. (60 × 60 cm).

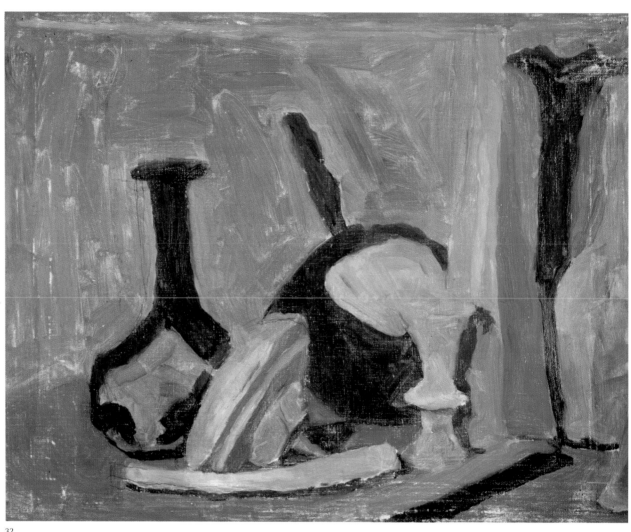

32

32.

Still Life, 1936.
Oil on canvas,
18 3/4 × 23 5/8 in. (47.5×60 cm).

the self-consciously flamboyant "bad boy" aspect of Futurism is tenuous, at best. He may have found their modernism attractive in principle, even entertaining; apart from the 1914 exhibition, he is supposed to have attended some Futurist performances—most likely cacophonous "concerts"—but it is difficult to relate any of Morandi's pictures with the insistently linear, scratchy evocations of modernity and motion of Boccioni, Severini, and their colleagues. He certainly didn't share their much vaunted rejection of the art of the past, no matter how wholehearted his embrace of the most innovative ideas of the present. Morandi did become friendly with the lapsed Futurist Carlo Carrà, drawing closer to him as his work evolved through a kind of archaism into the poetic "realism" of his metaphysical works. Carrà published several articles and reviews that favorably mentioned the work of his Bolognese colleague. Morandi was officially, if briefly, connected with the Metaphysical School, specifically with the painters, including Carrà, associated with the magazine *Valori Plastici*. This is evidenced by his participation in several important group exhibitions, one that toured Germany in 1921, and one held in Florence the following year. For the latter, De Chirico wrote admiringly about the young Bolognese's work in the catalog. Whether Morandi was, properly speaking, ever a member of the Metaphysical School in an ideological sense is another matter. The exciting part of Morandi's history is to be found in his gradual accumulation of one man and group exhibitions in Italy and elsewhere, of medals and prizes, and of innumerable books, catalogs, and articles by distinguished critics, over the years—impressive evidence of international acclaim that grew steadily during the artist's lifetime and has continued to grow after his death.

Nevertheless, there is little to capture the popular imagination in the image of Morandi that emerges from the legend or from the record of his admirable career, and nothing in the recollections of even his closest friends corresponds to the conception of the anguished, driven twentieth-century artist beloved of the mass media. There is nothing about inner torment, flamboyant actions, troubled love affairs, or any of the other flashy clichés that the movies and pulp fiction have associated with the making of art. The reminiscences of Morandi's friends, far from revealing unexpected scandals, simply reinforce the impressions we receive from photographs of the artist, both formal and informal, whether they show him at work, with his friends, or on various public occasions. Morandi, we can see, was tall, handsome, and rather self-effacing—no mean accomplishment given his

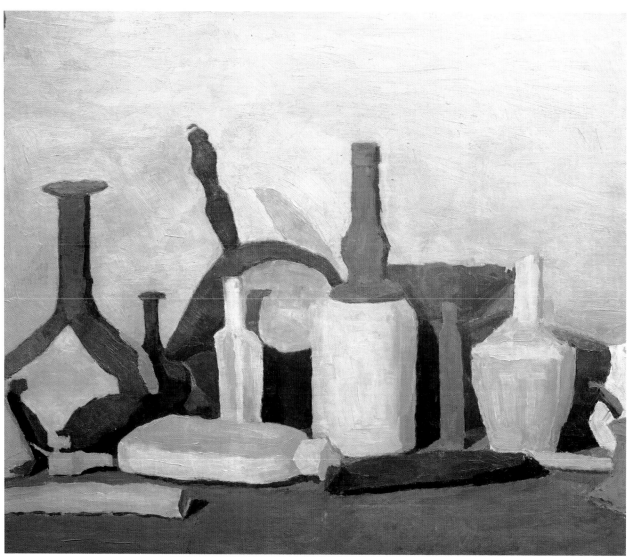

33

33.

Still Life, 1937.
Oil on canvas,
24 $^3/_8$ ×30 in. (62×76 cm).

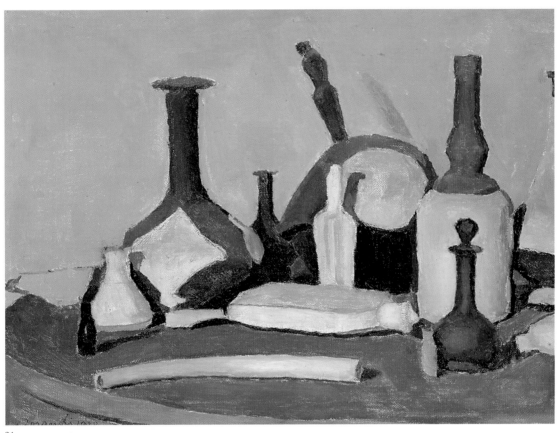

34

Still Life, 1938.
Oil on canvas,
15 $^{3}/_{4}$ × 20 $^{7}/_{8}$ in. (40 × 53 cm).

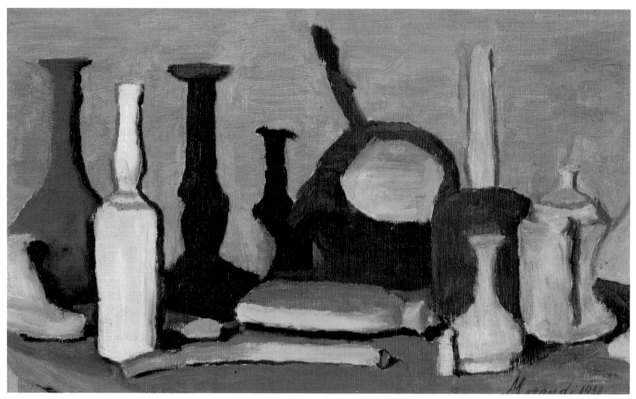

35

Still Life, 1938.
Oil on canvas,
9 ¹/₂ × 15 ⁵/₈ in. (24.1 × 39.7 cm).

height, which makes him stand out in group photographs; he wore glasses when he worked, and he dressed like a prosperous workman. His friends describe him as near-sighted, modest, correct, reticent, a little vague; they characterize him as shy, provincial, observant of his religion—a believer, who regularly attended mass at Santa Maria dei Servi, an austerely beautiful church with a spectacular portico and a Cimbue madonna. It was conveniently located a short walk from both the Via Fondazza and the Academy, and was traditionally a place of worship not for artistocrats or for the bourgeoisie, but for the working class and servants. Morandi is said to have gotten along well with the artisans in his neighborhood and to have enjoyed chatting with them, as much, apparently, as he enjoyed conversations with his artist and writer friends. According to Paolo Ingrao, a close acquaintance of many years, the key to Morandi's character was the word "humility."[20] Photographs (and the occasional self-portrait) give us a strong impression of what the artist looked like, but in some ways, he comes most immediately alive in an article written in 1928 by Leo Longanesi—a vivid description of Morandi in the street that makes him sound like a cross between one of Alberto Giacometti's walking men and the French film director Jacques Tati's enchanting alter ego, M. Hulot:

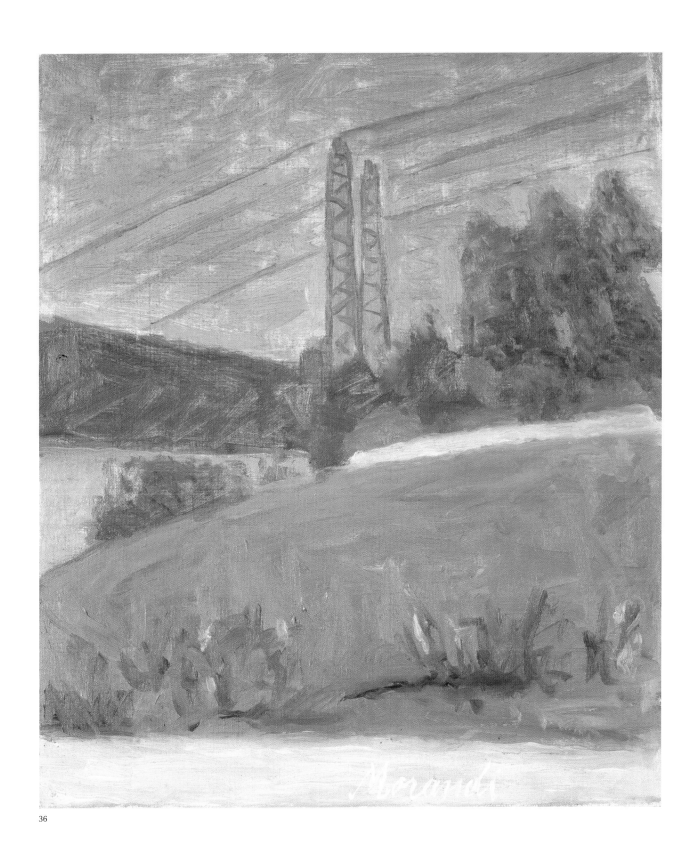

36

36.
Landscape, 1940.
Oil on canvas,
18 $^7/_8$ × 16 $^1/_8$ in. (48×41 cm).

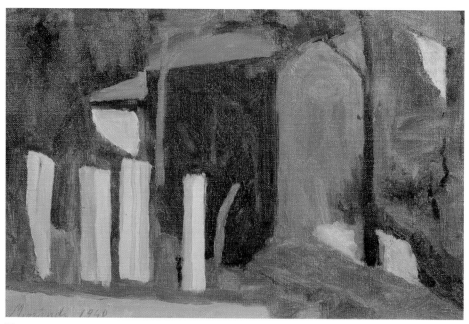

37

38

37.

Landscape, 1940.
Oil on canvas,
13 3/4 × 19 3/4 in. (35 × 50 cm).

38.

Still Life, 1940.
Oil on canvas,
18 7/8 × 21 1/8 in. (47 × 52.8 cm).

39

39.
Landscape, 1940.
Oil on canvas,
$18\,^{7}/_{8} \times 20\,^{7}/_{8}$ in. (48×53 cm).

When he walks, he seems an old schooner, viewed prow-first; his soft felt hat perched on top of his head is a perfect top-gallant sail, touching the clouds. He dawdles, brushing against the walls, dragging his feet, with the air of someone wearing long pants for the first time.[21]

Longanesi observes how the lanky, preoccupied Morandi stood out in Bologna, "a bourgeois town where everyone is short and plump" and, it goes without saying, where everyone is neatly and properly dressed. The painter, however, was conspicuous for being "tall, thin, in rather worn, loose-fitting clothes."[22]

And yet, it is ultimately the image of Morandi's studio that most impresses itself on our minds, perhaps more so than any description or photograph of the man himself—a silent, crowded place, a monastic cell (not an ivory tower) dedicated to visual contemplation and work. Today, the legendary Bologna studio has been faithfully reconstructed at the Morandi Museum, infinitely touching but slightly sanitized, in contrast to John Rewald's description of the studio when he visited Morandi in 1964, shortly before his death:

> No skylight, no vast expanses, an ordinary room in a middle class apartment lit by two ordinary windows. But the rest was extraordinary; on the floor, on shelves, on a table, everywhere, boxes, bottles, vases. All kinds of containers in all kinds of shapes. They cluttered any available space, except for the two simple easels. . . . They must have been there for a long time; on the surfaces of the shelves or tables, as well as on the flat tops of boxes, cans or similar receptacles, there was a thick layer of dust. It was a dense, gray, velvety dust, like a soft coat of felt, its color and texture seemingly providing the unifying element for these tall boxes and deep bowls, old pitchers and coffee pots, quaint vases and tin boxes . . .[23]

(This description has a curious effect on our reading of some of Morandi's pictures. The apparently daring color shifts between the planes of certain objects in the still lifes become absolutely literal transcriptions of the deadening, profoundly

40.
Objects in Morandi's studio.
Photo: Duane Michals.
Courtesy Stephen Haller
Gallery, New York.

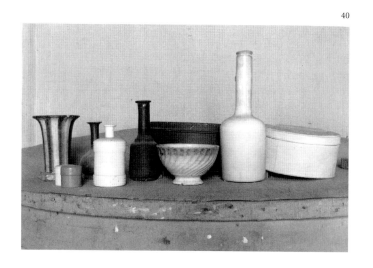

40

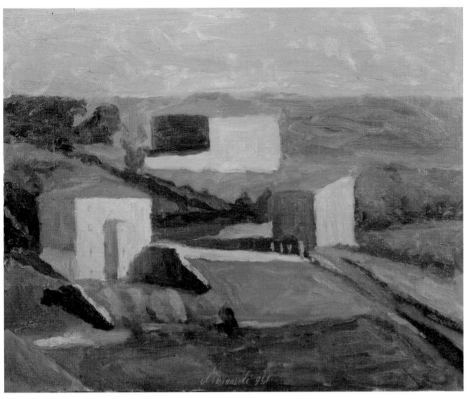

41

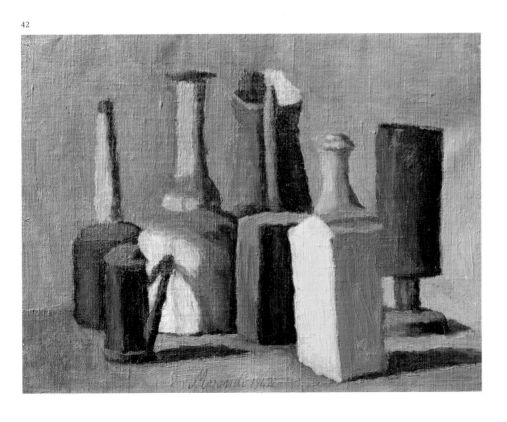

42

41.

Landscape, 1941.
Oil on canvas,
14 5/8 × 15 3/4 in. (37 × 40 cm).

42.

Still Life, 1942.
Oil on canvas,
11 7/8 × 15 3/4 in. (30 × 40 cm).

47

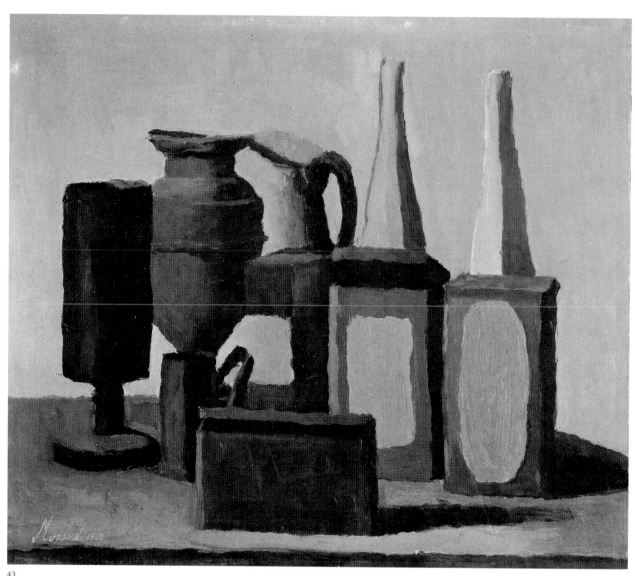

43

43.

Still Life, 1942.
Oil on canvas,
15×16 ½ in. (38×42 cm).

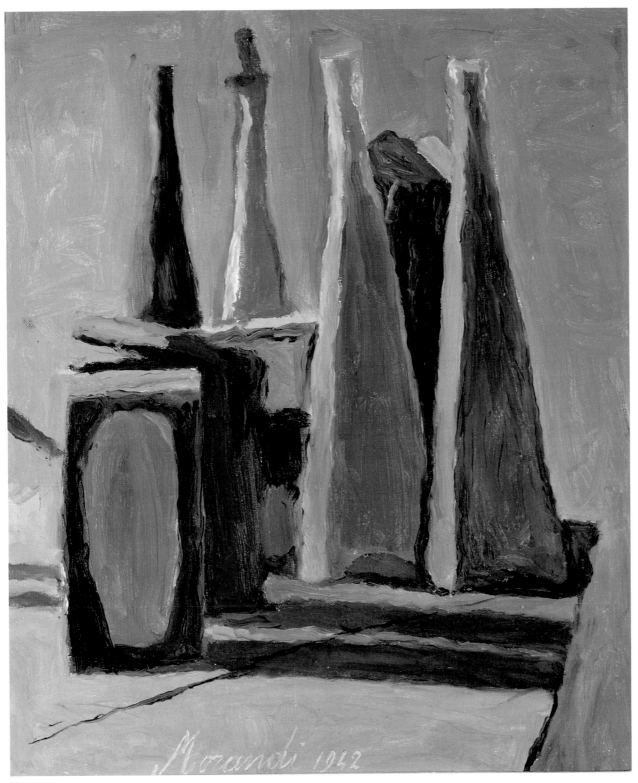

44

44.

Still Life, 1942.
Oil on canvas,
18 1/2 × 16 in. (47 × 40.5 cm).

altering effects of a layer of dust on the color and texture of horizontal surfaces.)

Little else makes Morandi more vivid than these descriptions, certainly not his letters, which are guarded, formal, and largely unrevealing—except in their evident unwillingness to reveal. They almost invariably close with old fashioned, formulaic courtesies, even to close friends. Morandi's published correspondence with his friend and patron, Luigi Magnani, is fairly typical, consisting of a series of letters spanning twenty years, during which time the Morandi and Magnani families exchanged gifts and visits, and a large number of the artist's works—including Morandi's only "commissioned" painting—entered Magnani's collection. (Because of his special interest in music, Magnani, a Beethoven scholar, asked Morandi to paint a still life with musical instruments. Morandi agreed, but rejected the valuable antique instruments Magnani provided as models, preferring instead a battered trumpet and guitar scavenged from a local flea market.)[24] The letters are addressed throughout to "Dear Magnani;" the polite form of the second person is used unfailingly; and while the letters are signed "your very affectionate Morandi," they also often include such stilted stock phrases as "I am pleased to send, also on behalf of my sisters, best wishes for the coming Christmas and New Year to you and your parents," or "I think of you with affection and greet you warmly, begging you to pay my respects to your parents."[25] Ingrao, in his memoir, recalls Morandi apologizing for continuing to use the formal *Lei* "after so many years," explaining that he even said *Lei* to Lamberto Vitali, one of the scholars who most closely associated with Morandi and who eventually cataloged his work.

Among the only breaks in this facade of formality are the artist's letters to Raimondi, whose friendship with Morandi dated from about 1916, when the aspiring critic was a student at the University of Bologna. The published correspondence dates from July 1919, after the young man of letters had published an article about Morandi and reproduced some of his work in *La Raccolta*, the short-lived but ambitious and important vanguard review Raimondi and his friends founded in Bologna. Morandi signs himself "yours very affectionately," as he did when writing to many other friends, but he addresses Raimondi as *carissimo* and, exceptionally, uses the informal, intimate *tu.* More important, these letters offer insight into the artists who interested Morandi, especially the old masters, and the artists with whom he was in contact, particularly in the early years. In this way, the letters confirm influences and connections suggested by the evidence

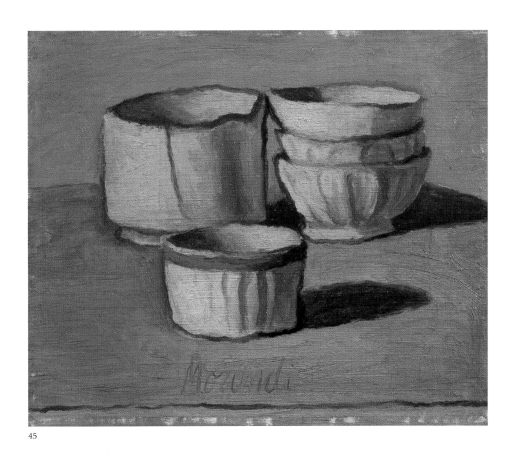

45

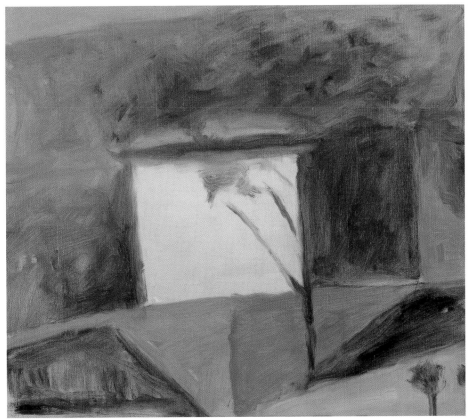

46

45.

Still Life, 1943.
Oil on canvas,
$9^{7}/_{8} \times 15^{3}/_{4}$ in. (25×40 cm).

46.

Landscape, 1943.
Oil on canvas,
$12^{7}/_{8} \times 15$ in. (32.8×38 cm).

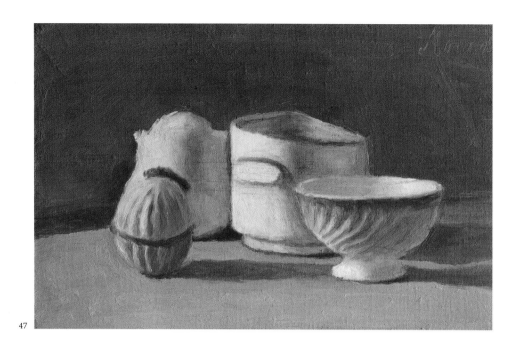

47

48

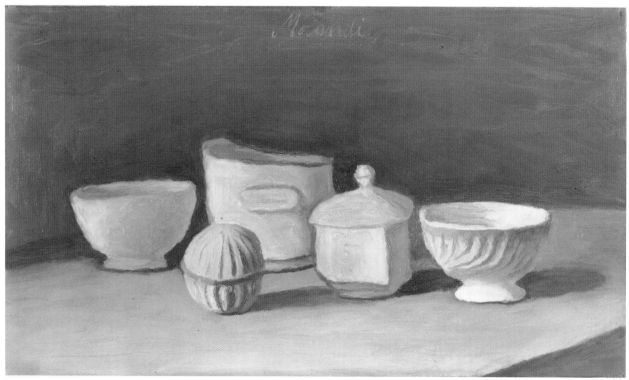

52

of Morandi's work. De Chirico and Carrà are often mentioned: Carrà visited Morandi, and commented on several pictures in the studio; De Chirico had to be reassured that Morandi's failure to send pictures to exhibitions by the *Valori Plastici* group in Rome was due to lack of money, not pride.[26] Sometimes Morandi's enthusiasms are unexpected. The letters to Raimondi indicate, for example, that he sought reproductions of works by Caravaggio and Orazio Gentileschi—artists whose intense, theatrically lit dramas, enacted by boldly modeled, large scale figures, would seem to be the antithesis of Morandi's cool, restrained, small scale still lifes. His interest in Caravaggio, however, was not casual; with Raimondi, Morandi traveled to Rome to study Caravaggio's paintings directly, just as they traveled to Florence to look at the work of the masters of the Renaissance. (It is worth pointing out that this interest in Caravaggio predates Morandi's friendship with the celebrated Caravaggio expert, Roberto Longhi.) Many of Morandi's other predilections seem more understandable, in light of what we know of his work; he reported to Raimondi that he looked at works by Uccello, Ingres, and Delacroix in Florence, and thought that the Delacroix suffered by being hung near the Ingres. He mentioned copying a Raphael portrait and asked for photos of Giotto's frescoes in Padua.[27]

The art books in Morandi's library attest that he was a man of wide-ranging and unexpected tastes. The presence of handsome volumes on Seurat, Chardin, Corot, Cézanne, Georges de la Tour, Giotto, and Piero della Francesca serves to confirm our understanding of Morandi's preferences, but what are we to make of equally impressive books on Grünewald, Jacques Villon, and Chinese porcelains? Perhaps they were gifts—Morandi seems to have welcomed presents of books on art—but if so, the givers were presumably aware of what would be acceptable. There are some conspicuous omissions as well. Matisse is represented only by a book of drawings, even though the two painters had much in common including their devotion to traditional subject matter, their passionate belief in the importance of nuance and formal relationships, and their reverence for Giotto. They are also divided, however, by an apparently unbridgeable gulf: for Matisse, unlike Morandi, formal rigor and visual invention were inseparable from an overwhelming sensuality and voluptuousness. Similarly, Braque is represented only by a book of graphics—an understandable addition to the collection of a master printmaker like Morandi, but odd for being the sole volume, given the affinities in the artists' choice of motifs and their fascination with subtle tonalities and the material expressiveness of the paint.

47.
Still Life, 1943.
Oil on canvas,
9×13⅞ in. (22.8×35.3 cm).

48.
Still Life, 1944.
Oil on canvas,
11⅞×20⅞ in. (30×53 cm).

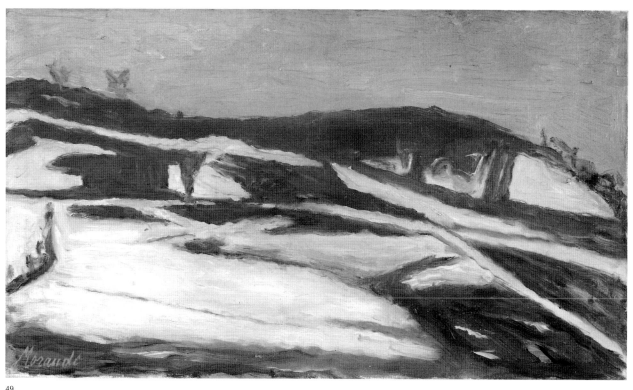

49

49.

Landscape, 1944.
Oil on canvas,
$12^{1}/_{8} \times 20^{7}/_{8}$ in. (31×53 cm).

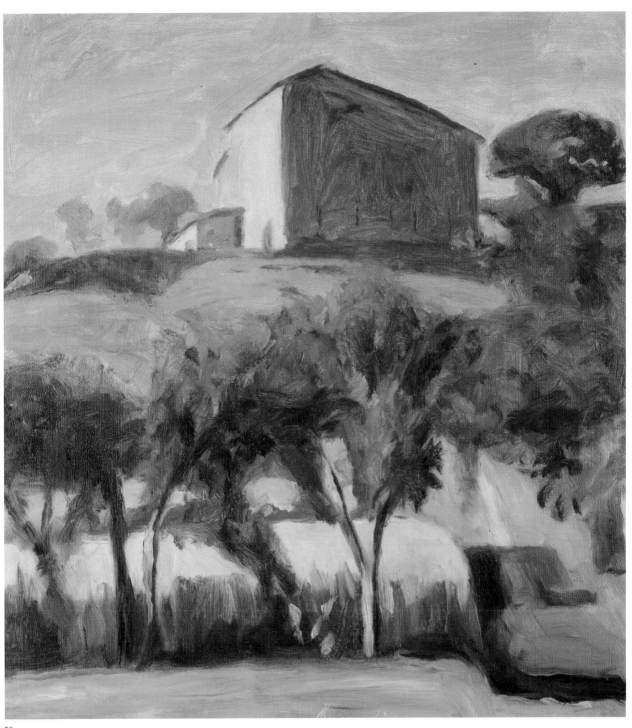

50

50.

Landscape, 1944.
Oil on canvas,
19 1/8 × 17 3/4 in. (48.5 × 45 cm).

Perhaps we should not be surprised at any of this. Raimondi's affectionate recollection of his years of friendship with Morandi makes it clear that the artist's tastes were eclectic and untainted by preconception. Raimondi tells us that Morandi admired the work of Luigi Bertelli, a minor Bolognese landscape painter of the late nineteenth century. Morandi maintained that Bertelli was "a complete painter, insofar as his temperament and his times would permit. But within those limits he did everything that he should have. Think what Bologna was then, what painting was here, in this city where there were only gentlemen and poor people. He was born to be a painter the way another was born to be a mason. . . . No one among us could have done better if he had been born at that time."[28]

It's difficult to know how much to trust Raimondi's quotations. His book, after all, is a memoir, but he apparently drew on notes made over the long duration of his close relationship with Morandi, and the statements he attributes to his lifelong friend seem extremely plausible. Raimondi says that Morandi described some pictures of Bertelli's that he particularly liked:

> Bertelli painted, here in the city, some landscapes of houses and the roofs of houses when there was snow. They were very beautiful things. The snow, as it appears in these landscapes of Bertelli's, becomes something enormously benign. It's like what happens when construction workers cover a rough plaster wall with a coat of whitewash.[29]

Bertelli's best pictures of this type, housetops with the edges of their roof tiles eloquently silhouetted against the snow, are constructed with an economical geometry and lack of pretention that make it easy to see why Morandi was attracted to them. They depend on an acute sensitivity to textures, and the appearance of surfaces that the poet and critic W. S. Di Piero has suggested lies at the heart of Morandi's art. Bertelli's cityscapes are oddly reminiscent of Morandi's pared-down images of the courtyard of the Via Fondazza—in sunlight, not snow—and of the rose-tiled rooftops visible from his studio windows.

Concrete, unromanticized reminiscences like Raimondi's, or the recollections and critical writings of others close to Morandi—Longhi, Vitali, Luigi Magnani, Cesare Brandi, for example—act as a counterweight to the Morandi myth. Together with the painter's extant correspondence and the texts of interviews he granted, they form a body of first-hand information that seems to offer some insight into the "real" Morandi. Ultimately, these

51.

Still Life, 1944.
Graphite on paper,
9 × 12 1/8 in. (23 × 30.7 cm).

52.

Still Life, 1946.
Oil on canvas,
9 7/8 × 17 3/4 in. (25 × 45 cm).

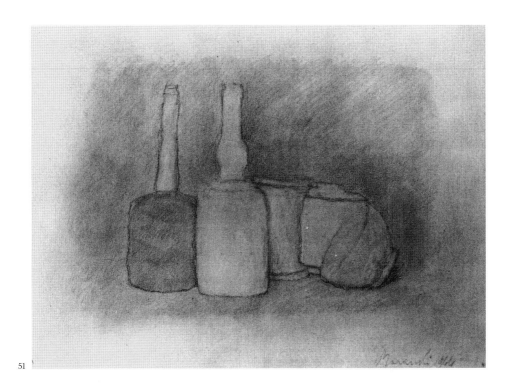

51

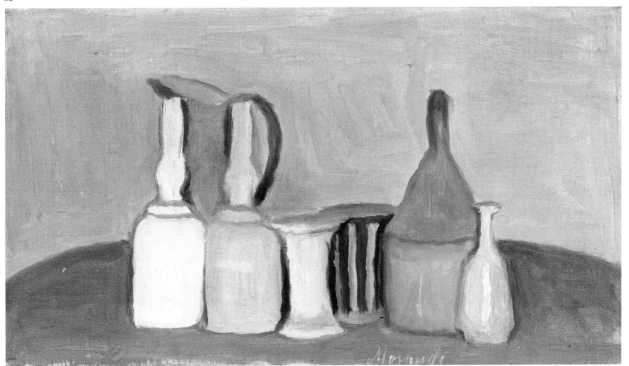

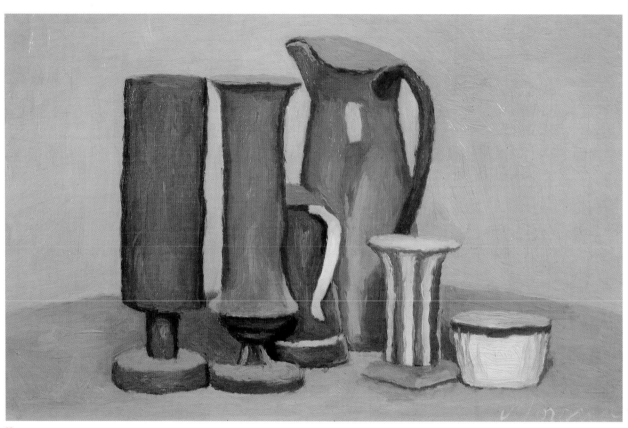

53

53.

Still Life, 1946.
Oil on canvas,
11 ³/₄ × 18 ³/₄ in. (29.9 × 47.7 cm).

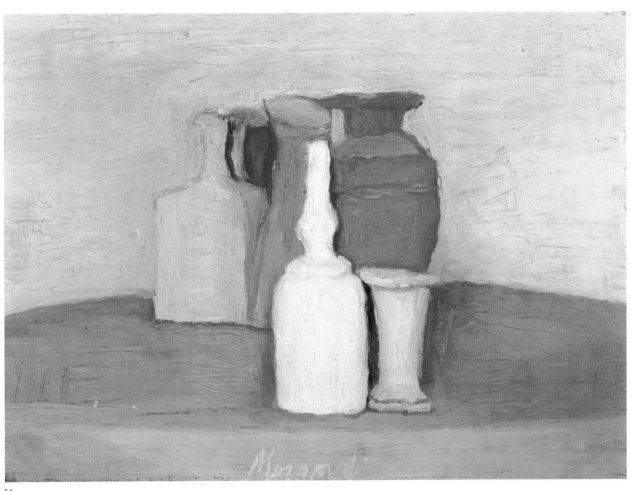

54

54.
Still Life, 1947-48.
Oil on canvas,
12×17¾ in. (30.5×43 cm).

comments and memoirs simply confirm what can be seen in Morandi's work itself: that things are more complex than they appear to be at first sight. The very characteristics that seem to set Morandi apart from the most "advanced" of his colleagues during the years of his maturity, and that provoked some observers to claim him as a conservative—his refusal to abandon recognizable imagery, his domestic and vernacular subject matter, the intimate scale of his work, and its apparently circumscribed themes are not evidence of a retreat from formal adventurousness. Quite the contrary, they are testimony to a rigorous, unceasing probing of the most fundamental issues of perception and of what a painting can be.

For Morandi, as for his much-admired Cézanne, this aspiration toward a kind of ultimate resolution in his painting was lifelong, and perhaps finally unobtainable. "A painting," he said to Raimondi, "even if it is small and has few things in it, is something so difficult to achieve in every part that you never know where you've gotten to. In any event, it's enough if you're pleased with nine tenths of it."[30]

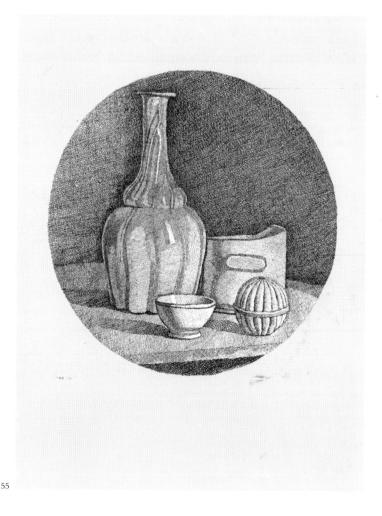

55.

Large Circular Still Life with Bottle and Three Objects, 1946. Etching on copper, 12³/₄ × 10¹/₈ in. (32.5 × 25.8 cm).

55

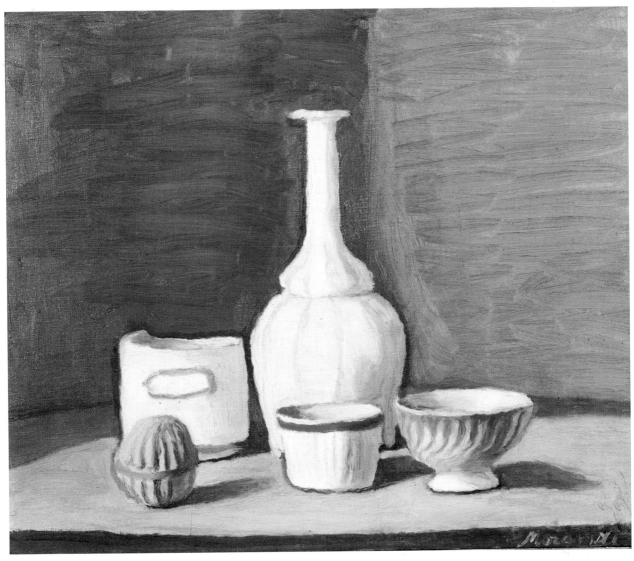

56

56.
Still Life, 1946.
Oil on canvas,
14 3/4 × 15 3/4 in. (37.5 × 40 cm).

57

58

57.

Still Life, 1947.
Graphite on paper,
9 1/2 × 11 7/8 in. (24×30 cm).

58.

Still Life, 1948.
Graphite on paper,
4 1/8 × 5 3/4 in. (10.3×14.5 cm).

59

59.

Flowers, 1947.
Oil on canvas,
13 × 11 ⁵/₈ in. (33 × 29.5 cm).

III

Bologna in Morandi's day, as now, was no provincial backwater, but a pros-
perous middle class city that boasted of one of the oldest, most respected
universities in Europe. News of the latest and most challenging ideas in
many disciplines, including the fine arts, traveled rapidly among students,
faculty, and the thinking citizenry. It is clear from the works that have sur-
vived from Morandi's student years that the young painter was informed
early on about the modernist adventure, and responded enthusiastically to
what he knew. In some of his earliest works, for example, there are echoes
of the *Macchiaioli*, the group of nineteenth-century Italian painters roughly
equivalent to the Impressionists. They strove to evoke the experience of
outdoor light by constructing their pictures with boldly contrasting masses
of tone, modeling forms with broad touches of flat color known as *macchie—*
"spots" or "patches." One of the *Macchiaioli* was a professor at the Bologna
Academy until only a few years before Morandi enrolled, and to judge by
some of his surviving figure drawings from this student period, the retired
professor continued to exert some influence, even in absentia. A group of
ambitious heads are modeled with broad masses of tone that recall
Macchiaioli practice. Yet this was obviously not the only, or the most pow-
erful progressive influence on the young painter. From the same period,
there are works that seem to respond to quite different, even more experi-
mental models: drawings of heads delineated with contours as firm and
incisive as anything done at more or less the same time by the German
Expressionists, and an economical, powerfully modeled portrait of
Morandi's sister, Dina, painted in 1912, that teeters on the edge of Cubism.
He thought highly enough of this work to exhibit it in the historic 1914 show
at the Hotel Baglioni. (This head is often discussed in relation to the work
of André Derain, although it is impossible to say with certainty just what
was known about Derain in Bologna before 1912.)[31]

It can be argued that the very existence of such pictures is evidence
that Morandi consciously declared his allegiance to modernism and chose
to present himself to posterity as an advocate of modernist ideas; instead of
destroying these works, as he did the majority of his youthful efforts, he

60

60.

Still Life, 1948.
Oil on canvas,
14 3/4 × 17 3/4 in. (35.5 × 30.5 cm).

61

61.
Still Life, 1948.
Oil on canvas,
$10^{1}/_{4} \times 15^{1}/_{8}$ in. (26×38.5 cm).

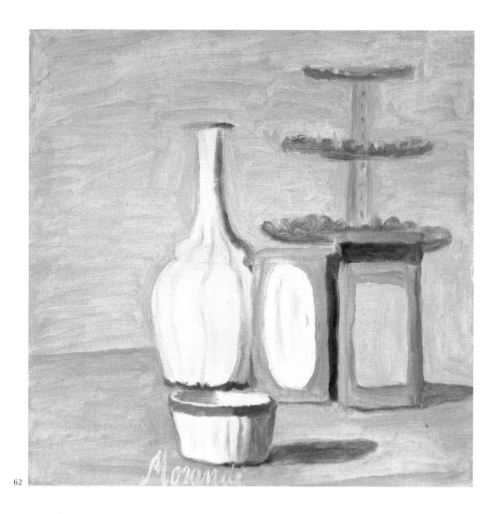

62

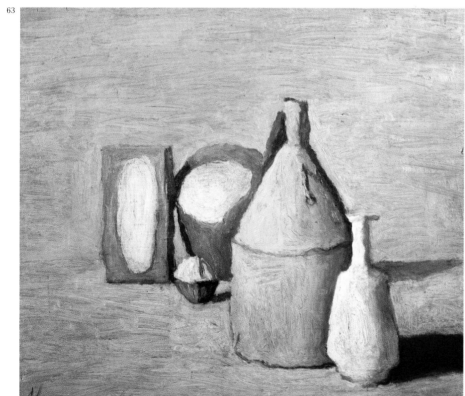

63

62.

Still Life, 1948.
Oil on canvas,
14 1/4 × 14 1/4 in. (36 × 36 cm).

63.

Still Life, 1948.
Oil on canvas,
13 3/4 × 15 3/4 in. (35 × 40 cm).

"legitimized" them, turning them into tantalizing witnesses to the origins of his mature style. This is not to discount Morandi's reverence for some of the most accomplished art of the past, or his respect for his heritage as an Italian painter, both of which inform all his work. It is significant, however, that his taste in old master art does not seem to have extended to the ambitious, often bombastic works of his celebrated Bolognese antecedents, splendidly represented in the Academy's collection; he clearly preferred Giotto, Uccello, Piero, and Masaccio. Morandi was said to be passionate, too, about the solemn twelfth-century reliefs by Benedetto Antelami in Parma. In addition to the work of these rather austere masters, he admired the more modest, disciplined efforts of what were once called the Bolognese "primitives,"—local painters from the early Renaissance. He even owned some examples of these, along with works by the eighteenth-century Venetian painter of intimate interiors, Pietro Longhi, and prints by Rembrandt, Ingres, and Pissarro. It is plain, however, that no matter how much he admired the work of his ancestors, as an aspiring young artist, Morandi was most strongly attracted to the adventurous art of his own day and most powerfully stimulated by it.

Morandi was well informed about the most innovative and serious ideas proposed by painters of his day. Since a number of European magazines and newspapers offered any interested Bolognese, in those years, current critical writing, news, and reproductions of modernist works—supplemented, no doubt, by discussions and debates at the Academy and the cafés of the university town—there is no way of knowing precisely when Morandi became aware of what, but his work is evidence that he took full advantage of any opportunities to study examples of adventurous art both in reproduction and first hand. It is quite possible, for example, that he was aware of Cézanne as early as 1908, through the well-illustrated book published that year by Vittorio Pica, or by 1909, from reproductions in the magazine *La Voce*.[32] Other encounters are better documented and can often be dated precisely. Morandi traveled to the Venice *Biennale* of 1909 and 1910, and the Rome International Exposition of 1911, exhibitions that included works by Courbet, Monet, Pissarro, and Cézanne, as well as by Renoir, Henri Rousseau, Matisse, Braque, and Picasso, among others. Raimondi, recalling the early years of his long friendship with Morandi, comments on the "incredible diversity" of the painter's "imaginary museum," a mental collection that ranged, he says, from Caravaggio to Ingres to Seurat, and also included Henri Rousseau, via Wilhelm Uhde's pioneering book on the Douanier.[33]

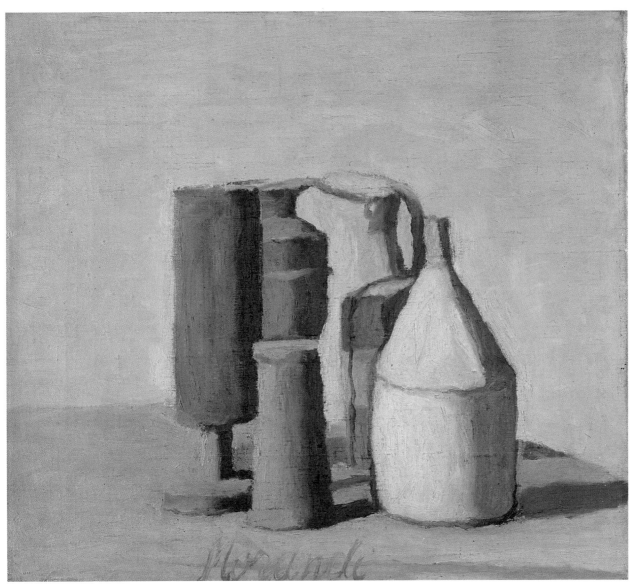

64

64.

Still Life, 1948.
Oil on canvas,
14 1/4 × 16 1/8 in. (36 × 41 cm).

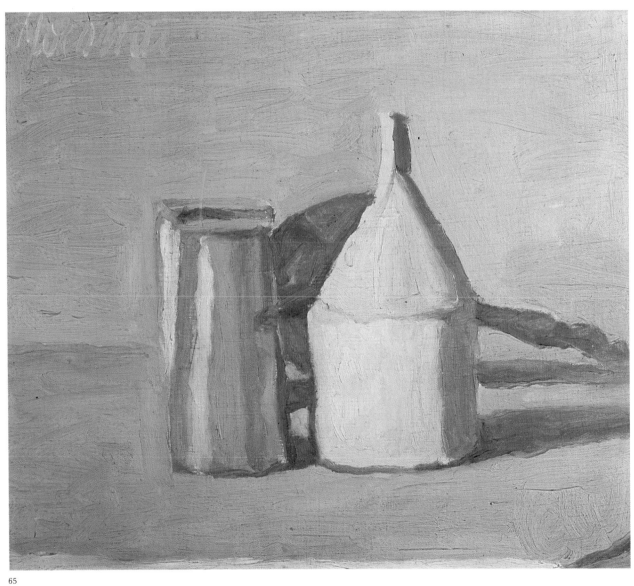

65

65.

Still Life, 1948.
Oil on canvas,
12×14 in. (30.5×35.5 cm).

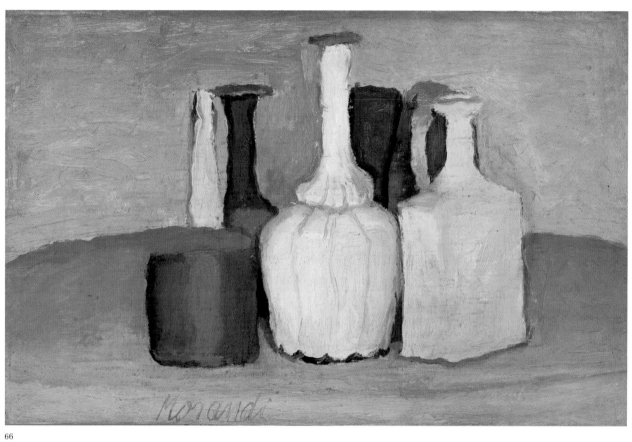

66

66.

Still Life, 1948.
Oil on canvas,
10 1/4 × 15 3/4 in. (26 × 40 cm).

Morandi's works of the early teens reflect these models in a wide variety of ways, as though the young painter were testing the possibilities offered by a range of different approaches. Yet he was not simply trying on styles the way one might try on overcoats, but rather exploring alternatives that he found challenging and sympathetic. It might be more accurate to say he was assimilating a new vocabulary, perhaps even an entire new language, that allowed him even greater personal expression. While, for example, Morandi's stylized, wispy vases of flowers from this formative period can easily be described as indebted to Rousseau's stiff, engaging prototypes, they can also be read as prefigurations of the highly individualized, rock-solid flower paintings, often based on bouquets of paper roses, that Morandi painted at intervals during his mature years. In the same way, many of his early landscapes point both back to the art that influenced the young painter and ahead to some of his most identifiable works. Economically, but freshly rendered, and bathed in cool, dusty light, they signal Morandi's awareness not only of the *Macchiaioli*, and of his fellow Bolognese, Bertelli, but also of French Impressionism and Cézanne in particular. At the same time, these formative efforts are already stamped with the unmistakable traits we attribute to the mature artist.

Asked who influenced him most during these crucial years, Morandi listed Cézanne and "the early Cubists"[34] (unspecified, but most probably Braque and Picasso) and among the artists of the past, Piero della Francesca, Masaccio, Uccello, and Giotto. The link among these sources is the powerful articulation of form and mass that declares itself in the work of all of these artists—radiantly clear in Piero and Giotto, crisp to the point of hardness in Uccello, softened by pellucid light in Masaccio, disrupted and fused with the materiality of paint in Cézanne, dislocated and pulsing in the Cubists. It takes nothing away from Morandi's originality to recognize that his understanding and admiration of these chosen ancestors informs his work throughout his career, with each exerting a different degree of influence at different times, sometimes quite visibly, sometimes disappearing altogether.

Among Morandi's Italian forebears, Giotto is arguably the most important; his powerful example of massive, swelling figures against schematic landscape settings, both figures and setting reduced to essential masses and planes, reverberates through Morandi's work, perhaps even forming the basis of his most characteristic still life images. Morandi's pared-down compositions in which a volumetric oilcan, a monumental

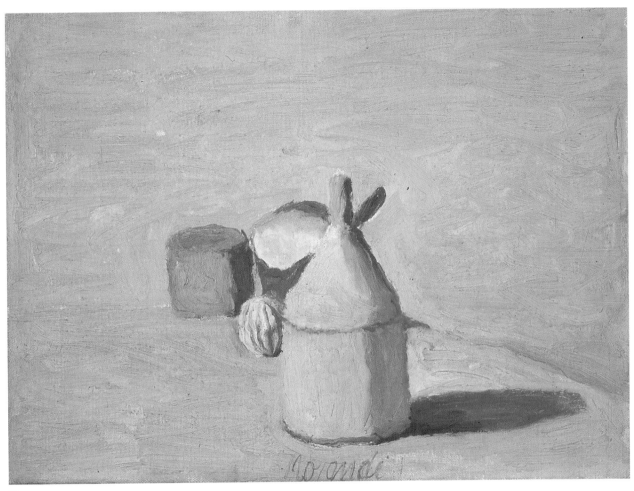

67

67.
Still Life, 1949.
Oil on canvas,
11 $^{7}/_{8}$×15 $^{3}/_{4}$ in. (30×40 cm).

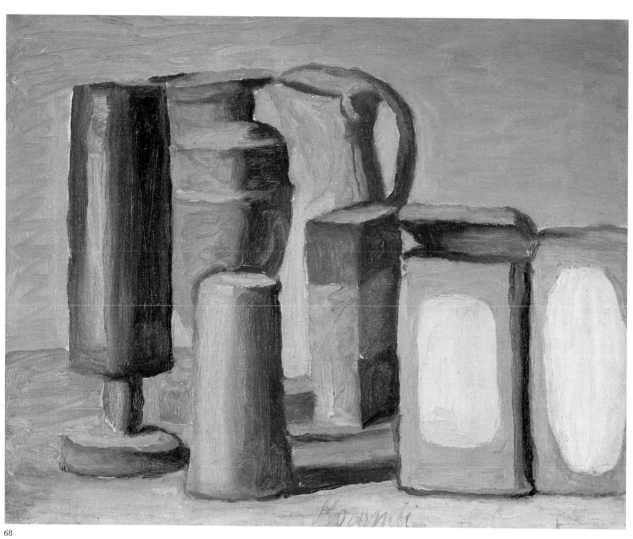

68

68.
Still Life, 1949.
Oil on canvas,
14 1/4×17 7/8 in. (36×45.2 cm).

74

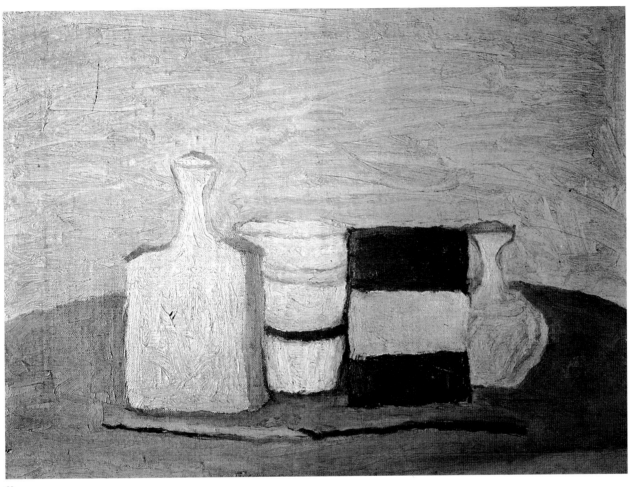

69

69.
Still Life, 1949.
Oil on canvas,
14×19¾ in. (35.5×50 cm).

bowl, and a mysterious, fluted sphere enact solemn rituals in a shallow space, defined only by two opposing planes, can be read as domesticated, abstracted equivalents of Giotto's thundering religious dramas. Analogies can be made, too, between Morandi's serried bottles and narrow pitchers, and Piero's groups of preternaturally still, columnar figures. Yet if there is a single artist who remained a significant presence for Morandi, from first to last, it is not an Italian old master, but a French modernist: Cézanne. Just as he did for Matisse and Braque, Cézanne served Morandi lifelong as a model of excellence and intensity, a source of inspiration and confirmation, a paradigm to measure himself against. During the mid-teens, the years of Morandi's most obvious experimentation with pictorial languages, Cézanne's presence is particularly evident, both directly, in Morandi's landscapes and still lifes, and indirectly, in his exploration of Cubist space.

Morandi's fascination with the obvious appearances of Cubism—its ways of referring to space and form, its subject matter, its palette, its hatchings and broken strokes—lasted only a few years, from 1914 to about 1916, and resulted in only a small number of canvases. Perhaps most notable among these are a still life from 1914, now in the Centre Georges Pompidou, Paris, and a landscape from the same year, from the Jesi Collection, now in the Brera, Milan. That Morandi was well aware of Picasso and Braque's works of only a few years earlier is manifest in such pictures, but whether this knowledge was acquired from direct experience, reproductions, or from intermediary sources such as the Futurists' Cubist-derived works of the period, is open to debate. What is incontrovertible is Morandi's understanding not simply of the appearance of Cubism, but of its spatial language. If he was looking at Futurist pictures, he certainly ignored their suggestion of literal fragmentation and their composite planes employed as diagrams of motion. The trees in Morandi's most overtly Cubist paintings of these early years are not constructed with superficially faceted, angular forms, but with staccato, near-transparent planes whose accumulation articulates a dense mass. A uniform brushiness knits everything together—the planes of objects and of space, spotting and dotting and all—as though the materiality of paint and the fact of the surface of the canvas far outweighed any incidentals of division or reference. In a larger sense, Cubist conceptions persisted in Morandi's art throughout his career. His work remained deeply informed by his understanding of Cubist structure and its iconography, even years later, when he devoted himself to making images of solid, unfragmented, apparently conventionally rendered objects. It seems obvious that Morandi's

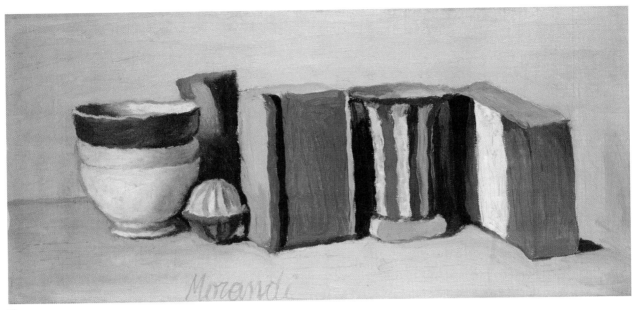

70

Still Life, 1951.
Oil on canvas,
8⅞×19¾ in. (22.5×50 cm).

nominal subject, the table top world of the still life, with its familiar cast of characters—the pitchers, boxes, oil cans, and the like—has its cognates in the Cubist dramatis personae of studio appurtenances and the clutter of the café table. More important, his *real* subject was identical to that of the Cubists: the exploration of a series of subtle relationships of part to part, plane to plane, and part to whole. Morandi's nominal subject matter was not chosen at random any more than was that of his Cubist ancestors. The objects with which he set up his still lifes, like the places that triggered his landscapes, clearly had profound resonance for him, both formally and iconographically. Like Braque, whose few landscapes are of places within a short distance from the places he lived, and who said that he turned to painting still lifes because things that were beyond the reach of his hand seemed to have no reality for him, Morandi was obviously deeply engaged by the specifics of what he chose to paint, but his art is not driven by a desire to replicate the appearances of actuality. Quite the contrary. He seems always to have striven to reveal the orderly, logical formal relationships that can be extracted from the randomness of mere appearance—an aspiration that could be said to link him with Cézanne and Chardin as much as the Cubists.

Morandi's most overtly Cubist paintings in the teens often exploit a narrow, vertical format that seems to provide some kind of rationalization for the apparent shattering of conventional form within the boundaries of the canvas. The sheer pressure of the squeezed rectangle, it seems, has caused the objects on the table to fragment, the landscape to dissolve into

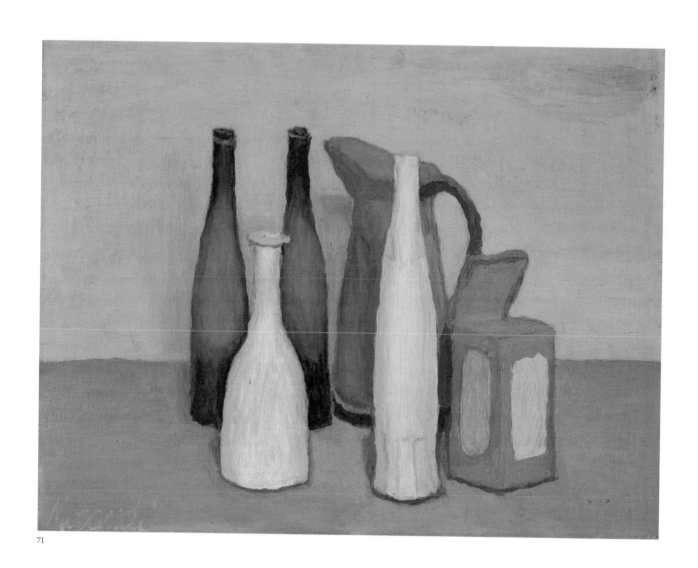

71

71.

Still Life, 1951.
Oil on canvas,
13×16⁷/₈ in. (33×43 cm).

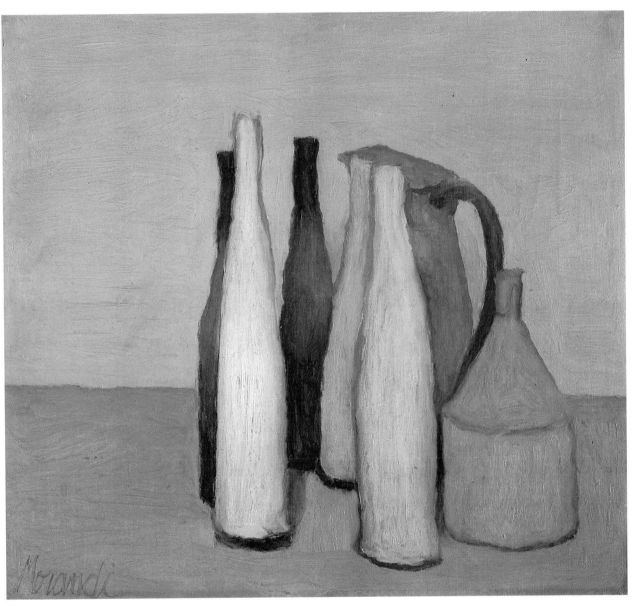

72

72.

Still Life, 1951.
Oil on canvas,
14 1/4 × 15 3/4 in. (36 × 40 cm).

a mass of planes and short, detached brushstrokes. Such acute sensitivity to the relation of the part to the whole, to the inseparable nature of internal structure and external proportion, is typical not only of the young painter exploring alternatives, but of the mature Morandi at his most hermetic, in his serial still lifes. Many of the painter's best known still life images were explored, not singly, but in slowly plotted series, with small changes from picture to picture. A single element may be added or deleted from a basic configuration of familiar objects; it may be moved to a new position among its fellows or have its orientation altered. It is relatively simple to see how (and why) such alterations, which have wholly to do with shifts in spatial and formal relatedness, are also translated into color changes within a given sequence of pictures; repositioning an object in space creates new conditions of light, a new relationship to adjacent surfaces, a new relationship to the artist's eye. What is less immediately apparent is that each small change in internal composition provokes a new size and proportion of the canvas, in an inextricable linkage of cause and effect, and of part to whole, first signaled in the narrow Cubist paintings of 1914–16.

In a sense, Morandi's next coherent group of pictures, his so-called Metaphysical paintings, are aberrations in the evolution of his characteristic approach. In fact, his whole relationship to the artists referred to as the Metaphysical School—including Carrà, De Chirico, and De Chirico's brother, Alberto Savinio—is itself problematic, but it is undeniable that Morandi had a brief, but real connection with the movement. And while throughout his career he was hardly isolated or ignorant of what his colleagues and contemporaries were doing, the period between 1918 and 1919 when he produced his handful of Metaphysical still lifes marks a rare moment when he was actually connected to an identifiable group of vanguard artists. What makes this even more interesting is that Morandi's colleagues were *the* Italian vanguard artists of the period, the originators of a movement that, while short-lived, had such widespread influence that it has been described as changing the face of Italian painting at the end of World War I.[35] The history of the movement is complex and riddled with acrimonious contentions about who originated what. (To compound the difficulty, the name "Metaphysical School" was never used by Carrà, De Chirico, or Morandi to describe themselves.) Like Surrealism, which was indebted to the Metaphysical movement and indeed, eventually "appropriated" De Chirico for its own ends, the Metaphysical movement had its origins in literature, and it was partly through a literary connection that Morandi was associated with

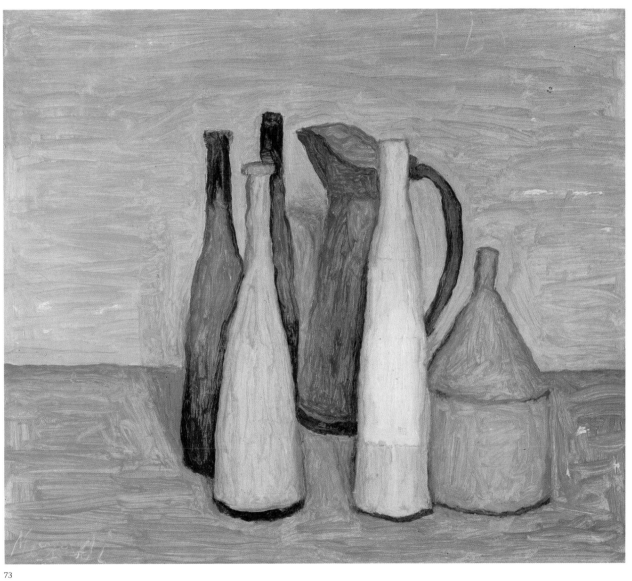

73

73.
Still Life, 1951.
Oil on canvas,
15 3/8 × 17 3/4 in. (39 × 45 cm).

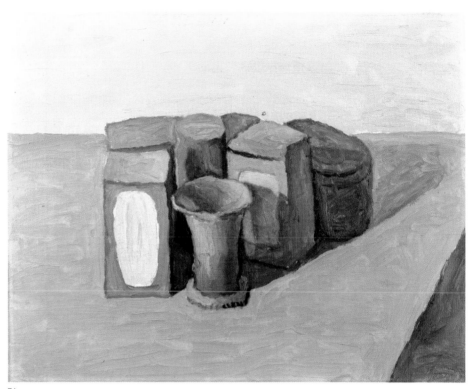

74

75

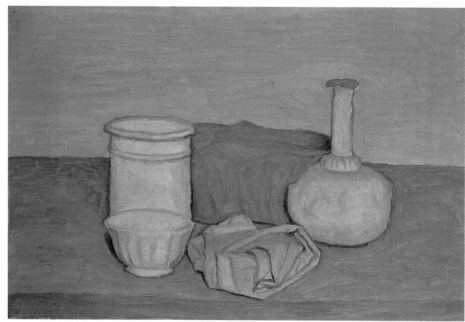

74.

Still Life, 1952.
Oil on canvas,
14×17⅞ in. (35.5×45.5 cm).

75.

Still Life, 1952.
Oil on canvas,
12⅝×18⅞ in. (32×48 cm).

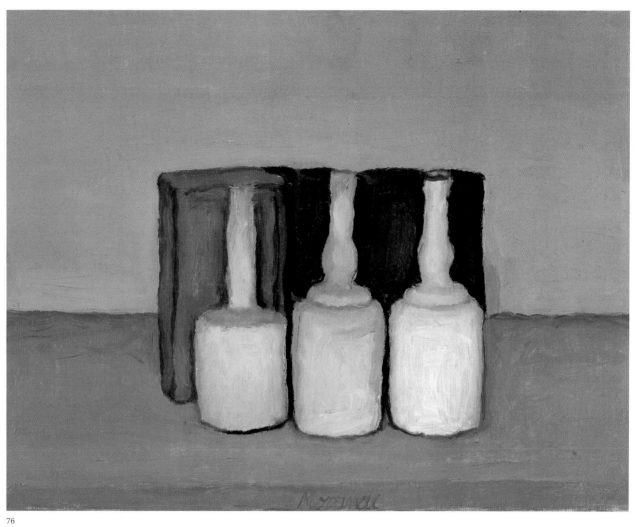

76

76.
Still Life, 1952.
Oil on canvas,
14×17⁷/₈ in. (35.5.×45.5 cm).

83

the "school." His initial link was through his friends Raimondi, Riccardo Bacchelli, and Clemente Rebora, who together founded a little magazine, *La Raccolta*, which published verse, prose, and critical essays by writers such as Filippo De Pisis, and artists such as De Chirico and Savinio, who were associated with the Metaphysical school. The magazine also published images by the artists, including Morandi, who were eventually referred to as the Metaphysical painters. During its short existence—about half a dozen issues were published between March 1918 and the beginning of 1919—the magazine was an important forum for adherents of the movement. It was also an important source of support for the artists who responded to the fundamental notions of the Metaphysical School: that things, even the most ordinary things, could serve as potent metaphors for highly charged themes; that the objects of the workaday world could mean far more than they seemed to the casual observer. The artist's role, in fact, was to reveal these heightened meanings, to encapsulate the reverberations that transcended mere physical appearance, to function, in short, as a seer. The now-familiar iconography of Metaphysical painting—the mannequins, the milliner's blocks, the drafting tools, and the like—were not simply objects, but surrogates for the human figure and for human activity, stand-ins at one remove from actuality, which is to say, meta-physical objects.

Morandi was well-informed about these notions through his close relations with the founders of *La Raccolta*, and specifically, through his contact with Carrà, whose work was reproduced and discussed in various issues. Carrà had long since abandoned Futurism and was exploring the possibilities of an aesthetic that was apparently completely opposed to his Futurist beliefs, rooted in the classical past and embodied by solid, clearly rendered forms. He had discovered De Chirico's mysterious, hermetic pictures in Ferrara—images of a world at once rationally rendered and wholly invented, freighted with both nostalgia for a heroic, mythological past and a keen awareness of the modern—and had been profoundly influenced by them. (Although De Chirico was the originator of this approach and Carrà the follower, Carrà exhibited his versions of De Chirico's imagery before the works that inspired them became widely known, and hence was perceived to be a founder of the new movement.)

Morandi's eight or so Metaphysical still lifes are, in a sense, orthodox Metaphysical pictures, closely related to Carrà's efforts of the same period. They deploy the usual cast of characters beloved of the Metaphysical painters, including a milliner's bust-length dummy, *squadre*—drafting tools

77

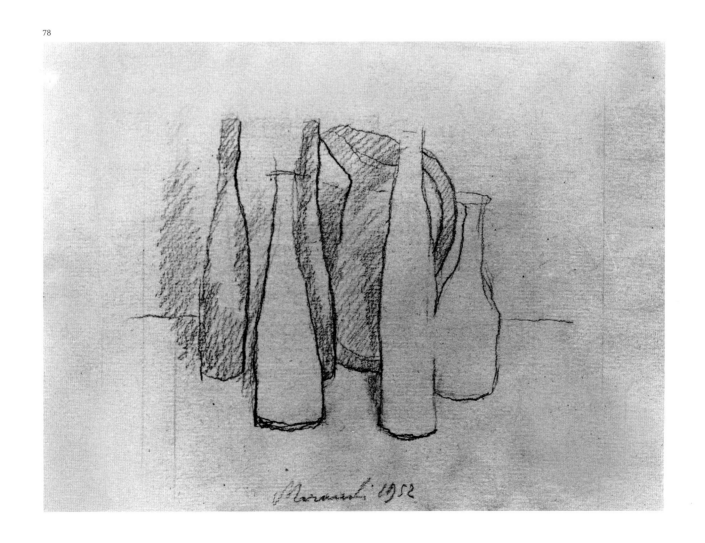

78

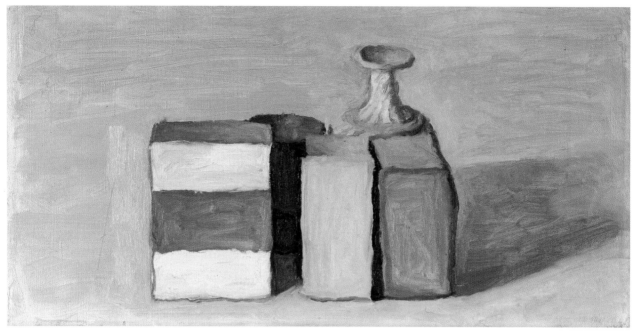

79

79.

Still Life, 1953.
Oil on canvas,
7 7/8 × 15 3/4 in. (20 × 40 cm).

for making angles—and enigmatic pattern shapes, all bathed in a slanting, golden light that casts long shadows. Like the work of the other Metaphysical painters, but unlike most of Morandi's earlier or subsequent works, these pictures are smoothly painted with a notable absence of surface inflection. They seem more overtly calculated than was Morandi's usual practice, apparently based, as Renaissance paintings are, on a system of rational mathematical proportions. Like Carrà's and De Chirico's works of the time, Morandi's paintings in this series read as stage-sets on which obscure dramas are enacted. Only their intensity, their insistent frontality, and their sense of mute, innate order seem particular to their author, rather than endemic to the Metaphysical School, and tie these works to his more characteristic still lifes of domestic objects.

The question remains whether these pictures, for all their apparent connections with Carrà's and De Chirico's works of the same period, are allusive, symbolic metaphysical constructions or, like the great majority of Morandi's pictures, simply still lifes. His contacts with writers and artists central to the Metaphysical movement notwithstanding, Morandi usually denied that his works of the period were anything *but* still lifes, however highly charged they might appear. Speaking to a young admirer, Stephen Haller, around 1964, he insisted (typically) that he had never painted anything other than what he could see.[36] Four decades earlier, in the publication most closely identified with the Metaphysical School, *Valori Plastici*,

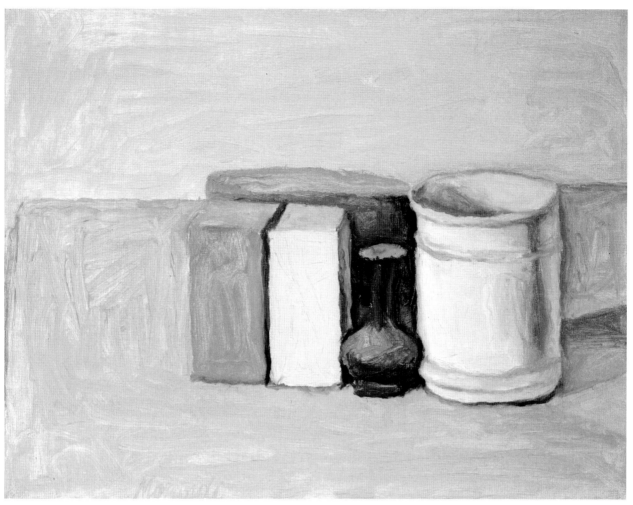

80

80.
Still Life, 1953.
Oil on canvas,
11 ¹/₂ × 14 ⁵/₈ in. (29 × 37 cm).

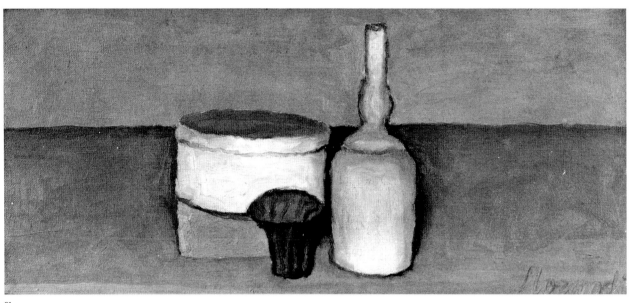

81

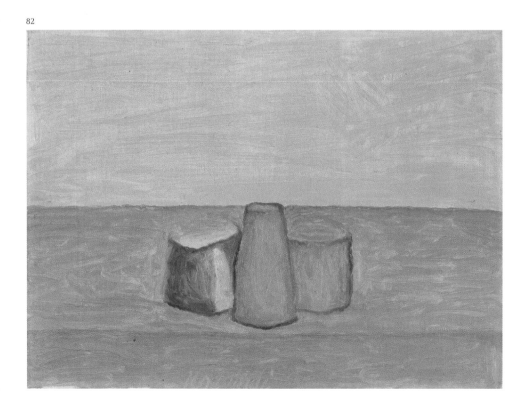

82

81.

Still Life, 1953.
Oil on canvas,
7 7/8×15 3/4 in. (20×45 cm).

82.

Still Life, 1953.
Oil on canvas,
13×17 7/8 in. (33×45.5 cm).

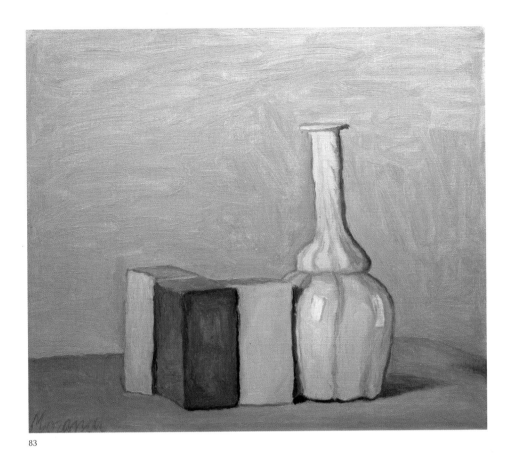

83

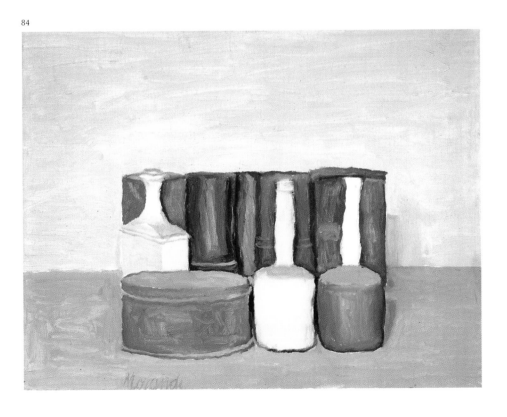

84

83.

Still Life, 1954.
Oil on canvas,
11 ⁷/₈×13 ³/₄ in. (30×35 cm).

84.

Still Life, 1954.
Oil on canvas,
13 ¹/₄×18 ¹/₄ in. (33.5×46.3 cm).

(published from 1918 to 1922 and edited by Carrá, De Chirico, and Savinio) Morandi stated that he regarded still life painting as a way of transcending time, of confronting "inert objects," of meditating upon their "inherent beauty and spending an eternity in placid contemplation."[37] He reminded critics that he had owned his milliner's dummy as early as 1914, and insisted that he regarded it merely as yet another object that could be painted, although as more than one astute observer has pointed out, it is certainly true that he never chose to paint this particular object until 1918.[38] Among the most acute observations is that of a recent Morandi scholar, Paolo Fossati, who has noted that the protagonists of Morandi's "Metaphysical" pictures are the tools of the painting profession—the instruments of measurement, guidance, and correction of traditional picture making—"lexicons and dictionaries of painting, the rules of the game." He suggests that in a moment of daring experimentation, Morandi relied on the familiar tools of his trade to provide a point of stability at a time of flux.[39]

Could we then assume that Morandi's metaphysics is paradoxically empirical, even pragmatic, with the artifacts of his studio serving not as metaphors for the human condition, but as emblems of the act of painting itself? By extension, the compositions of *squadre*, milliner's dummies, and the like could be read as affirmations of Morandi's belief in the importance of art being about art—as modernist paradigms. And yet, the "Metaphysical" still lifes are among Morandi's most obviously historicist works. As a series they seem more about traditional painting values, more dependent on clear-cut modeling of forms, on dramatic staging, and on disguised facture than was, or would be, customary for the painter; they serve to remind us of his pilgrimage to study the works of Caravaggio, of his interest in Orazio Gentilleschi, of his copying a Raphael, of his owning a crisp little portrait etching by Ingres. Yet with the clear-sightedness provided by knowing the trajectory of Morandi's entire career, we can see that sources and impulses other than the rather circumscribed Metaphysical mode proved more fruitful to the maturing artist. It is understandable that he soon abandoned this approach—a decision that, as it turns out, led to paintings of far greater individuality.

From the evidence of the works made after 1919, it is clear that Morandi's aspirations for his art had shifted; far from wishing to have his painted images suggest transcendance of material fact—which is to say, to function as metaphor, he reveled in the particularities both of his chosen subject matter and of paint itself. The objects in the still lifes from the years

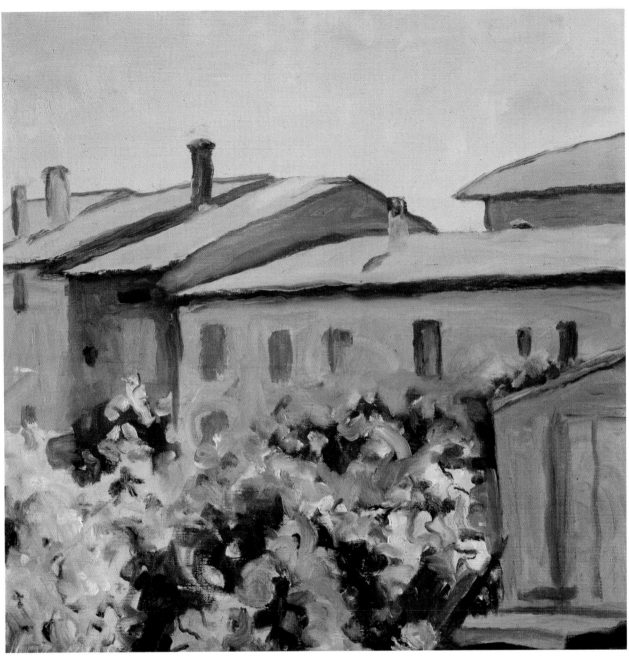

85

85.

Courtyard at Via Fondazza,
1954.
Oil on canvas,
22×22 in. (56×56 cm).

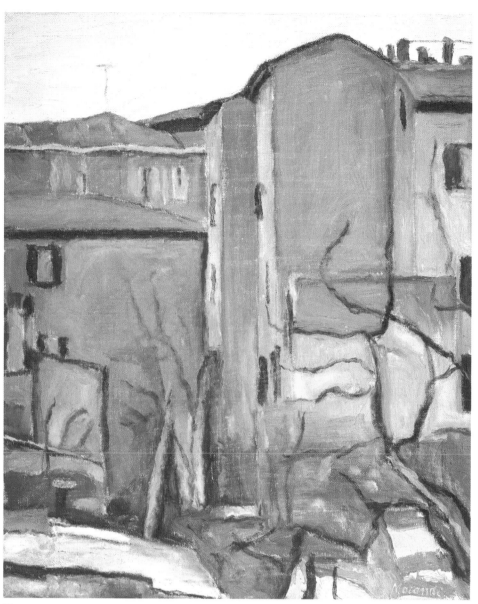

86

86.

Courtyard at Via Fondazza,
1954.
Oil on canvas,
22 1/4 × 17 1/4 in. (55.5 × 45.5 cm).

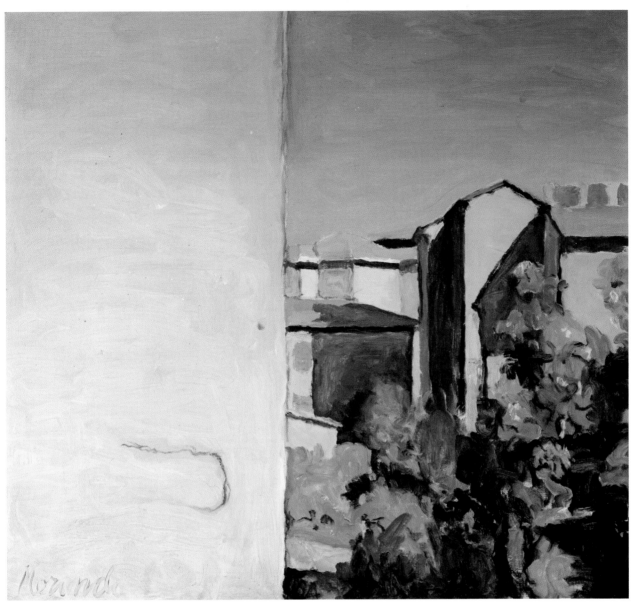

87

87.

Courtyard at Via Fondazza,
1954.
Oil on canvas,
19 1/4 × 21 1/4 in. (49 × 54 cm).

immediately following Morandi's association with the artists of *Valori Plastici,* and for the rest of his life, are no longer the tools of the studio, but the wholly domestic, utilitarian accoutrements of daily existence. (That they have been co-opted for studio use, divorced from their usual functions to serve as models, is another issue.) They are no less solid, no less firmly modeled than those of the "Metaphysical" paintings, but it is a solidity born of discrete, broad touches of fairly dense paint, not of seamless modulation of some neutral substance. It is as though Morandi, again at a moment of transition, looked for reassurance not only in the familiar and the quotidian, but in the artists of the past and the recent past whom he admired most: Giotto, Piero, and Cézanne. A still life now in the Kunstsammlung Nordrhein-Westfalen, Düsseldorf, is as golden and as uncannily still as any of the still lifes of mannequins and drafting tools, but with its water carafe, champagne flute, tipped *caffe latte* bowl, knife, little vase, and broken *croissants*, it is wholly of this world, not of some parallel metaphysical universe. The isolated objects, carefully spaced along the narrow table top, are as immutable as any of Giotto's monumental mourners or Piero's slender, high-belted women. Yet for all their echo of Renaissance prototypes, the angled knife, the slightly rumpled white cloth—an atypical inclusion for Morandi, who generally preferred to range his inanimate models on a surface as uninflected as a paved *piazza*—and above all, the faceted modeling of forms, immediately evoke Cézanne.

In 1920 Morandi visited the XII *Biennale* in Venice, where the French Pavilion included a room with twenty eight works by Cézanne. The effect on Morandi of his first-hand encounter with a large number of Cézanne's works is almost as palpable in many of Morandi's subsequent paintings as it is in the work of Picasso and Braque, following their experience in 1907 of the large Paris exhibition mounted to honor Cézanne's death the previous year. The impact of these shows on all three artists was remarkably similar; Cézanne's art seemed to offer them confirmation of their desire for change and an indication of a direction to follow.

Morandi almost immediately abandoned the overt allusions to a Cézannian model that are visible in some of his surviving works of the early 1920s, and arrived rapidly at a more personal way of handling paint and a more individual way of alluding to three-dimensional forms and flat planes. In many ways, however, the boundaries of what European

88.
Still Life, 1954.
Graphite on paper,
6 1/2 × 9 1/4 in. (16.3 × 23.5 cm).

89.
Still Life, 1955.
Oil on canvas,
9 1/2 × 13 3/8 in. (24 × 34 cm).

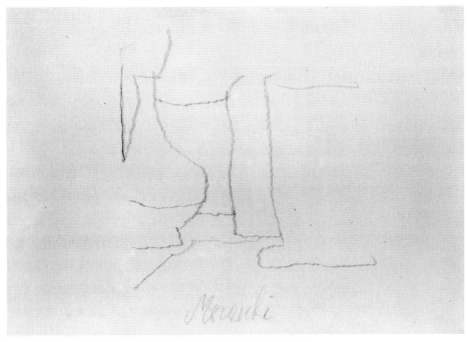

88

89

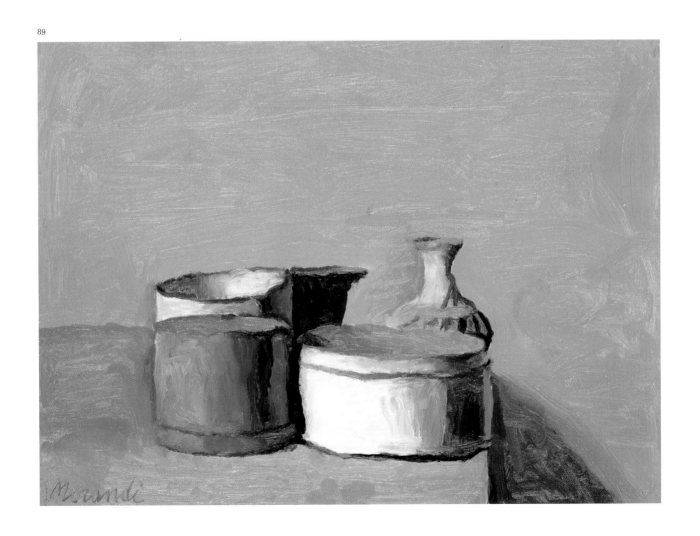

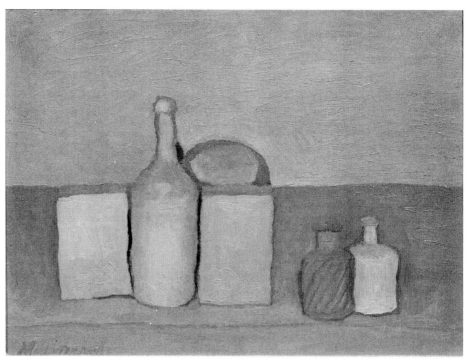

90

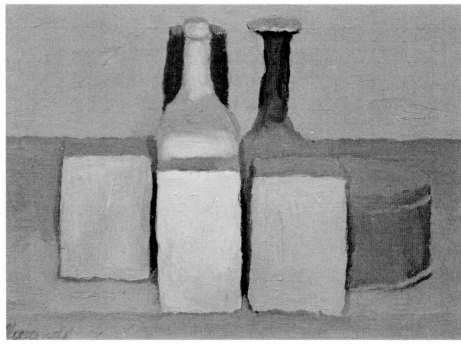

91

90.

Still Life, 1955.
Oil on canvas,
11 ⁷/₈×15 ³/₄ in. (30×40 cm).

91.

Still Life, 1956.
Oil on canvas,
9 ⁷/₈×15 in. (25×38 cm).

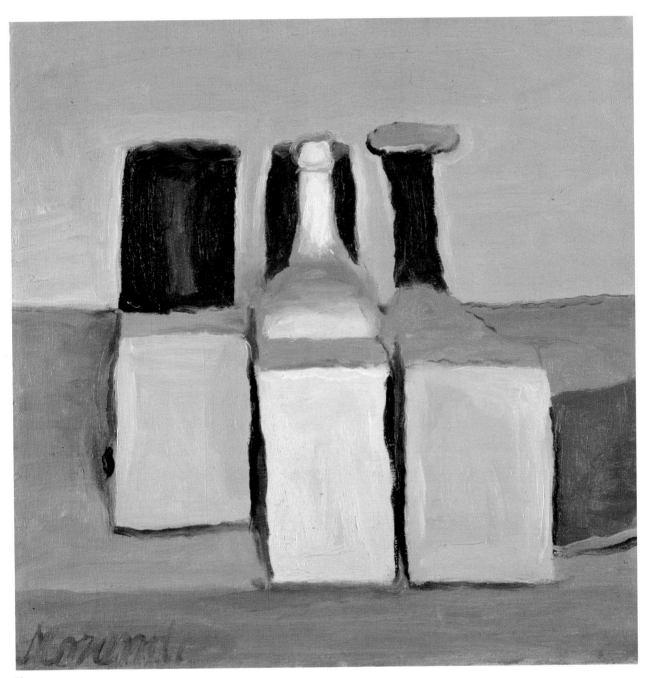

92

92.
Still Life, 1956.
Oil on canvas,
14 1/8 × 13 7/8 in. (35.8 × 35.2 cm).

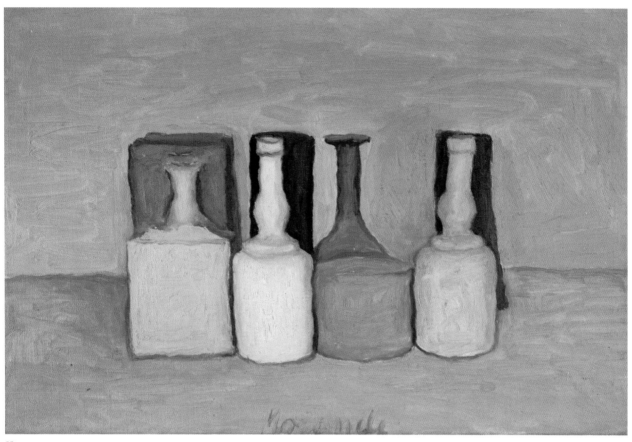

93

critics would call his "inquiry" over the next four and a half decades were already delimited by pictures like the Düsseldorf still life. They showed his desire, like that of Cézanne, to transform the intimate into the monumental, the ordinary into the absorbing, through painterly and pictorial invention. Further connecting these artists' aspirations is the tension they both court—tension between the illusion of solidity and the fact of paint, between reference to intense perceptions of the variousness of the existing world and an equally intense awareness of the unchanging actuality of the painting's flat surface. Whether his nominal subject is still life, landscape, or urban roofscape, the qualities of the best of Morandi's "post-Metaphysical" pictures persist for the rest of his life: material and emotional density, solemnity, frontality, hermetic self-sufficiency, and unpretentiousness—all qualities that can also be ascribed to the work of Cézanne. And as in the work of Cézanne, the driving force behind Morandi's pictures often seems to have been the sheer power of scrutiny, as though the act of looking were an act of possessing, of wresting deep feeling from apparently neutral subject matter.

93.

Still Life, 1956.
Oil on canvas,
11 7/8 × 17 3/4 in. (30 × 45 cm).

IV

Morandi's themes and, to a large extent, his style were essentially established by the time he was thirty. For the rest of his life as an artist, he remained committed to exploring a deliberately limited territory, in a nearly obsessive investigation of perception that produced images at once remarkable for their repetitiveness and for their subtle variation. But for all the conscious narrowing of his field of inquiry, for all the rigorousness of his self-imposed restrictions, he had no single way of making a picture. It often seems as though he were testing the limits of representation, now vigorously modeling and separating forms from one another and from their setting, now translating forms and setting alike into broad, un-inflected passages of paint. It even appears that each new picture, each new set of visual phenomena, no matter how familiar, elicits from him a different touch, a different way of orchestrating color. In fact, the more closely we look at Morandi's art, the more images we examine, the more individual each picture seems.

This is true even among the still lifes constructed of utterly familiar, repeated objects. In some, Morandi gangs those objects together so that they touch, hiding and cropping one another in ways that alter even the most recognizable features; in others, the same objects are treated as distinct individuals, gathered on the surface of the tabletop like an urban crowd in a piazza. In still others, objects are pressed and staggered like the buildings of a town on the fertile Emilian plains. In Morandi's closely linked "serial still lifes," apparently identical groupings of familiar objects, altered by the addition or subtraction of a single element, the presence (or absence) of one more bottle, one less box, as casually placed as an afterthought, can serve not only to completely shift the dynamic weight and the spatial logic of a given composition, but to change its color harmonies, and even the entire proportion of the picture.

Just as we become familiar with Cézanne's cast of characters—the white compote, the ginger jar, the dull, leafy fabric, the knife, and the country table—we easily come to recognize Morandi's protagonists—

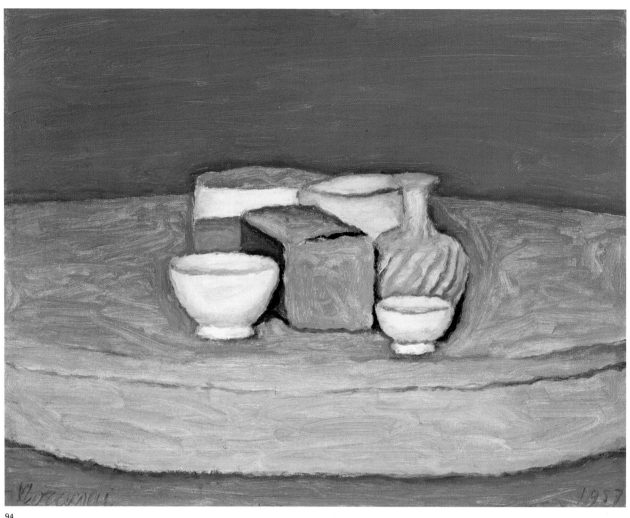

94

94.

Still Life, 1957.
Oil on canvas,
10 1/2 × 15 3/4 in. (27 × 40 cm).

95.

Still Life, 1957.
Oil on canvas,
9 7/8 × 15 3/4 in. (25 × 40 cm).

95

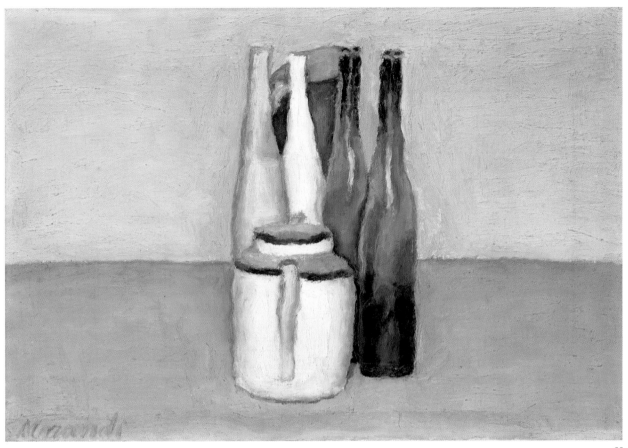

96

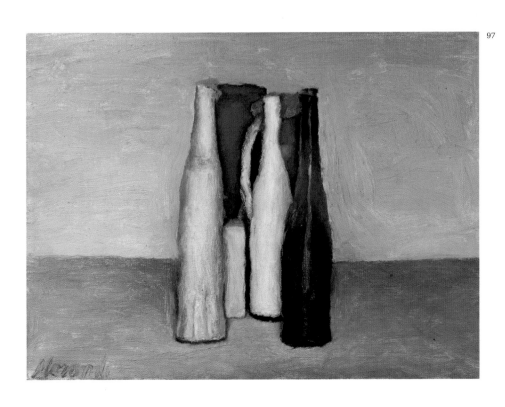

96.

Still Life, 1957.
Oil on canvas,
13 3/4×17 3/4 in. (35×45 cm).

97.

Still Life, 1957.
Oil on canvas,
9 7/8×13 3/4 in. (25×35 cm).

slender bottles, boxes, a tall pitcher with an imposing lip, a copper saucepan with a dent as characteristic as a well-known face, a family of obsolete oil lamps, their chimneys long since vanished. There is nothing remarkable about any of it. Quite the contrary, as attested by the sheer multiplicity of the stacks of crockery, the rows of bottles, the clusters of generic vases, and all the seemingly uncountable objects that covered the shelves and tables of Morandi's overpoweringly cluttered, monastic studio. Other "personages" that figure prominently in the still lifes are no less recognizeable, but are more difficult to name. Some seem almost industrial— a tapering oil can, a fluted ball, seemingly refugees from a repair shop— while others are intimate, luxurious, feminine—stoppered bottles and covered boxes that would seem at home on a woman's dressing table. Generic boxes and bottles seem to have been selected for their neutrality and anonymity, while a frivolous three-tiered cake plate with scalloped edges and a large shell with a rosy, sexually allusive interior, seem to to have been chosen for their sheer extravagance and improbability.

At first glance, Morandi's objects appear to be the detritus of domesticity, a collection of things once in daily use, but discarded either because they have suffered some kind of damage or because their contents have been exhausted. Confronted by such subject matter, it is easy to understand why Morandi has been compared so often with Chardin, whose still lifes also celebrated the ordinary and the humble, the trappings of the kitchen and the pantry, presenting them without sentimentality, but with scrupulous attention to their individual formal characteristics. Yet longer acquaintance with Morandi's still lifes makes their artifice more apparent. Clearly, these are studio set-ups, groupings created to be scrutinized, their plastic and visual relationships probed. The objects that provide their nominal subject matter may carry with them the memory of use, but it may not be the memory of use within the artist's own household. Neither are they sturdy peasant artifacts nor the decayed relics of aristocracy, but rather, generic flea market finds, essentially neutral objects, the leftovers of countless working class and middle class households (like Morandi's own) that, until recently, were the staples of northern Italian street markets.

Particularly after the 1940s, Morandi tended to emphasize the shapes and profiles of his objects in his pictures, distinguishing them by shifts in color, but unifying them with an even-handed, brushy application of paint. (In some drawings and watercolors, in fact, he recorded the

98

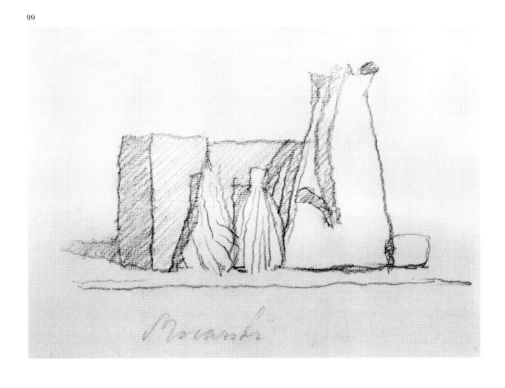

99

98.

Still Life, 1957.
Graphite on paper,
6 1/8 × 9 in. (15.7 × 23 cm).

99.

Still Life, 1958.
Graphite on paper,
6 1/2 × 9 1/2 in. (16.5 × 24 cm).

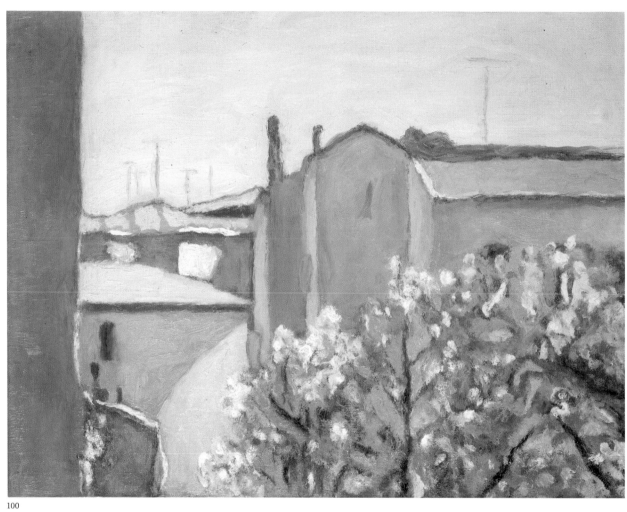

100

100.

Courtyard at Via Fondazza,
1958.
Oil on canvas,
12×16 in. (30.6×40.5 cm).

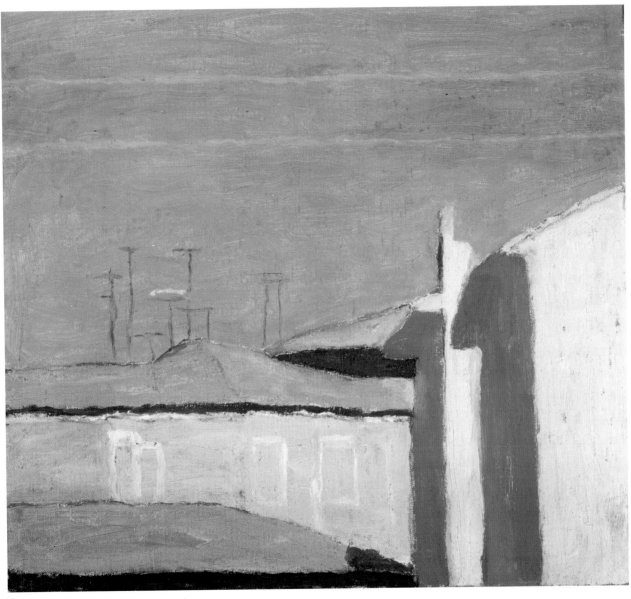

101

101.

Courtyard at Via Fondazza,
1958.
Oil on canvas,
17 7/8 × 19 3/4 in. (45.5 × 50 cm).

shapes between objects, rather than the objects themselves.) Yet it is clear from the objects that he hoarded in his studio that he often selected his subject matter as much for tone and texture as for form. The vases are opaque opaline glass or ceramic, dulled by age and dust. Matteness, dullness, and neutrality obviously counted a good deal for Morandi. Boxes and bottles, for example, were routinely stripped of labels or had identifying marks obliterated. The blanket of dust that so impressed studio visitors must have helped to homogenize disparate materials and reduce them to essential forms. In addition, many objects were brushed with flat white or grayish paint, to destroy reflections and anything accidental, as though the painter were striving to distance himself from the particulars of his circumscribed subjects in order to render them as abstract geometric archetypes.

In the same way, Morandi's landscapes and his urban scenes—economical views of the countryside near Bologna or of the *cortile* of his apartment house on the Via Fondazza—tread a narrow line between the essential and the particular. Some of the landscapes have the suddenness, instability, and rightness of an unexpected view from a moving train. Light and shade become abstractions momentarily made indentifiable (and tangible) by a transient association with walls, foliage, and earth. A narrow register of grayed, pearly tones, like the rock-solid construction of these pictures, simultaneously pays homage to Cézanne and evokes the special character of the Emilian landscape: the moist, hazy light of spring and fall, the dusty, baking sunshine of summer, the elementally solid farmhouses, the dense rows of silvery juniper, the harshly ploughed fields. The landscapes are soundless, distanced, almost dreamlike. (Brandi recalls Morandi's using binoculars to study a landscape motif from his studio window.) But there is nothing sentimental about the painter's view of modern-day Italy; there is no nostalgia for an idyllic past. Power pylons dominate a bare-bones landscape from 1940, now in the Museo Morandi, Bologna, with the arc of the wires echoing the swell of a gray-green field in the foreground. Television antennae and electric wires provide an excuse for subtle, delicate mark-making that mediates between sky- and roofline in a series of Via Fondazza paintings of the late 1950s.

This dialogue—or tug of war—between the specific and the elemental lies at the heart of Morandi's work. He seems to explore how much he can simplify before the objects and the places he obsessively returned to throughout his long career become unrecognizable. At other

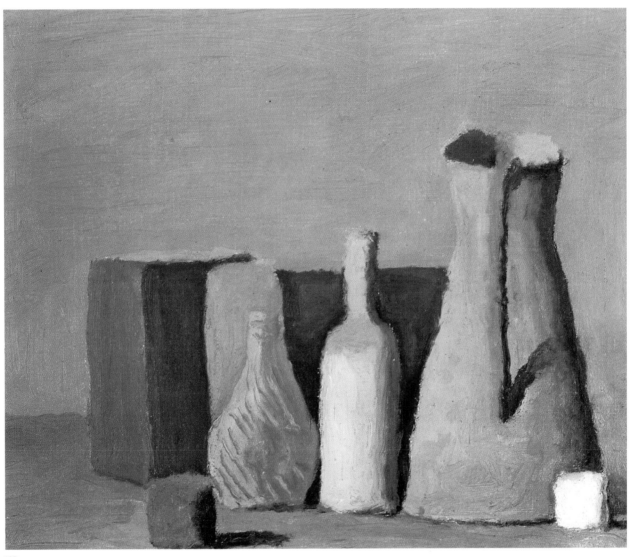

102

102.
Still Life, 1958.
Oil on canvas,
9^{7}/$_{8}$×11^{7}/$_{8}$ in. (25×30 cm).

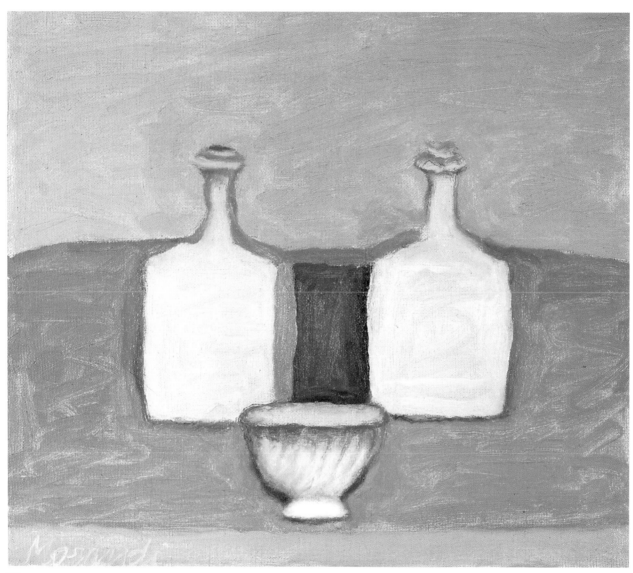

103

103.
Still Life, 1959.
Oil on canvas,
11 $^{7}/_{8}$×14 in. (30×35 cm).

times, he backs away from generalization, insisting on particulars to the point where each bottle and vase seems as individual as the subjects of the portraits he drew as a precocious art student. In his prints and drawings, the pendulum swings from near-naturalism that gives full weight to the complexities of three-dimensional illusion, to near-abstraction that suppresses the non-essential and reduces forms to disembodied outlines. (In the prints and drawings, both reference and abstractness seem, paradoxically, intimately related to the characteristics of the medium. Both his insistently hatched etchings, and his pencil drawings that are reduced to a few tremulous strokes that diagram the spaces between objects, are evidence of how attuned Morandi was to the physical properties of his materials.) Yet no matter how economical or elliptical his allusions, it is clear that Morandi was deeply attached to the objects and places that were his points of departure. It is equally clear that his retreat from the brink of abstraction to the security of reference was a deliberate choice, not a failure of nerve. While Morandi's paintings depend on abstract relationships, he was not an abstract painter, but rather a realist wholly absorbed by his perceptions, who distilled extraordinarily rarefied structures from his observations, anchoring his most extreme inventions in ordinary experience.

A trip to Bologna makes Morandi's double allegiance to observable reality and personal vision unequivocal, in the same way that a trip to Aix-en-Provence reveals both Cézanne's debt to the colors, forms, and light of his native landscape, and his staggering powers of invention. Morandi's roses and ochres, his dull browns and brick reds can be seen on any street in Bologna, just as the dusty greens of his landscapes can be found on any Emilian hillside. The pink brick, yellow stucco, and rosy stone of Bologna's streets seem intimately related not only to the color but to the very texture of Morandi's dry, almost stucco-like paint. The ubiquitous geometric red-tile roofs, weathered to a dull rose, further enlarge the pool of comparisons.

And then there are the arcades of Bologna, the seemingly endless *portici* that line the streets, making it possible for the inhabitants of a city famous for its rainy weather to move through it protected from the elements, comfortable and dry. The arcades are everywhere, on medieval buildings, on Renaissance *palazzi*, on nineteenth-century apartment houses, on postwar office blocks, even on fairly modest, turn-of-the-century streets of middle class apartments, such as the Via Fondazza. The arcades,

104

105

104.

Still Life, 1960.
Watercolor,
9 $^{7}/_{8}$ × 13 $^{3}/_{4}$ in. (25 × 34 cm).

105.

Still Life, 1960-64.
Watercolor,
5 $^{3}/_{8}$ × 10 $^{1}/_{8}$ in. (13.5 × 25.8 cm).

106.

Still Life, 1960.
Graphite on paper,
6 $^{1}/_{8}$ × 8 $^{5}/_{8}$ in. (15.7 × 21.8 cm).

106

107.
Landscape, 1962.
Oil on canvas,
11 ⁷/₈ × 13 ³/₄ in. (30 × 35 cm).

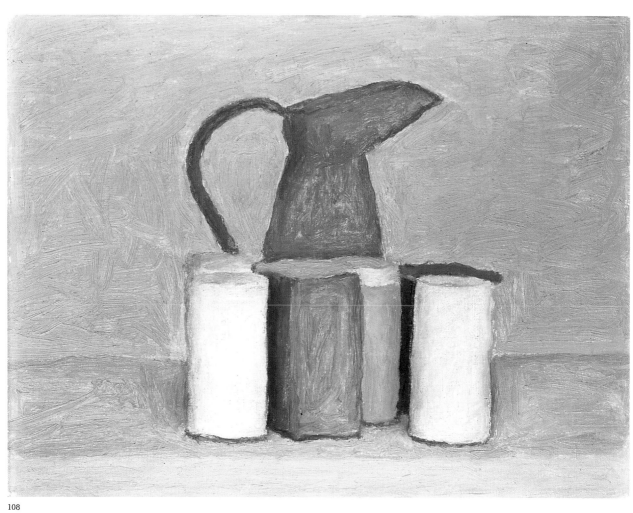

108

108.

Still Life, 1960.
Oil on canvas,
12×16 in. (30.5×40.5 cm).

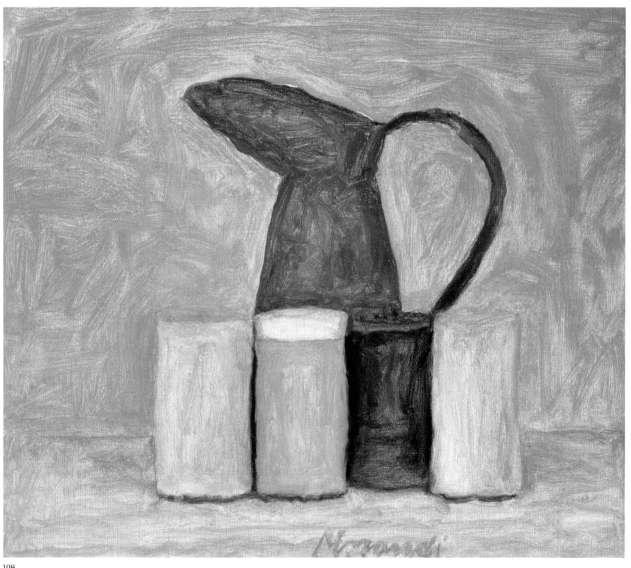

109

109.

Still Life, 1961.
Oil on canvas,
9 ⁷/₈ × 11 ⁷/₈ in. (25 × 30 cm).

110

110.

Landscape, 1962.
Graphite on paper,
9 ¹/₄ × 12 ³/₈ in. (23 × 31 cm).

like Morandi's still lifes, are always the same and always different. They vary in height, in rhythm, in the shape and form of their supports; some have pointed arches, some have round ones, some are flat-topped; some have columns, some have piers. The experience of moving through them, like the experience of seeing a substantial number of Morandi's paintings, makes one acutely sensitive to subtleties—to differences in space, to shifts in light, to variations in the patterns of walls and pavements. Is it far-fetched to assume that the almost daily experience of walking through the rose-red, arcaded streets of Bologna, an experience repeated for over seventy years, somehow found its way into Morandi's work? The writer, Umberto Eco, a longtime resident of Bologna and admirer of Morandi's art, describes his fascination as a high-school student on seeing a single still life in an exhibition in his provincial home town. He was puzzled then by how a small painting of not very much could hold his interest and challenge him, and puzzled later by how Morandi could seem so modern, when his work apparently had so little to do with what the young Eco had learned were the characteristics of modern art. He finally concluded that these qualities had something to do with the artist's ability to reveal variety in things that are apparently the same. This simultaneous quality of homogeneity and diversity, Eco believes, is typical of Bologna itself—so much so that he states that Morandi "can truly be understood only after

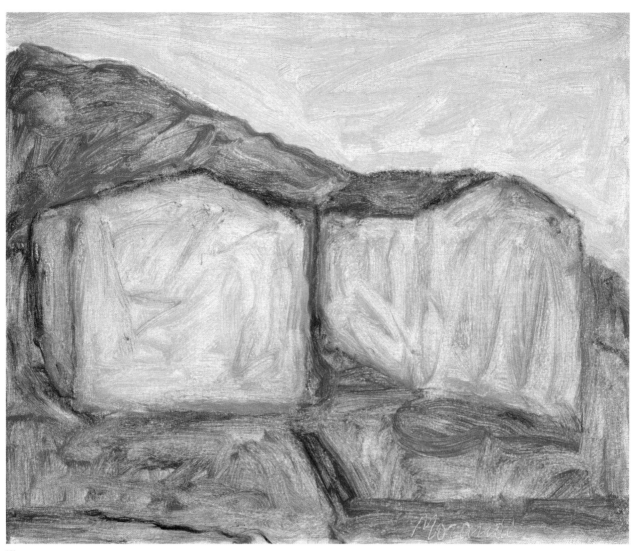

111

111.

Landscape, 1962.
Oil on canvas,
$10 \times 12\,^{3}/_{8}$ in. (25.5 \times 31 cm).

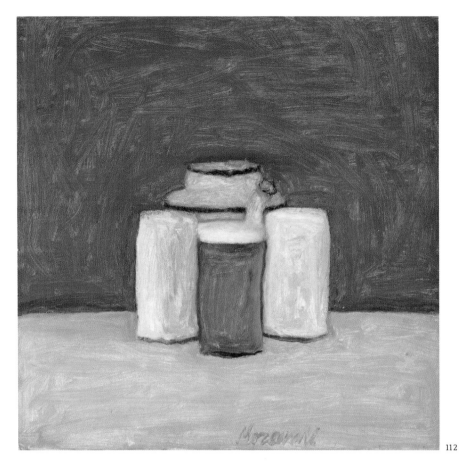

112

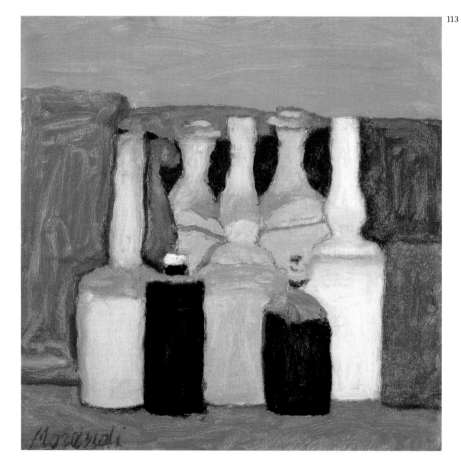

113

112.
Still Life, 1962.
Oil on canvas,
13³/₄×13³/₄ in. (35×35 cm).

113.
Still Life, 1962.
Oil on canvas,
11⁷/₈×11⁷/₈ in. (30×30 cm).

116

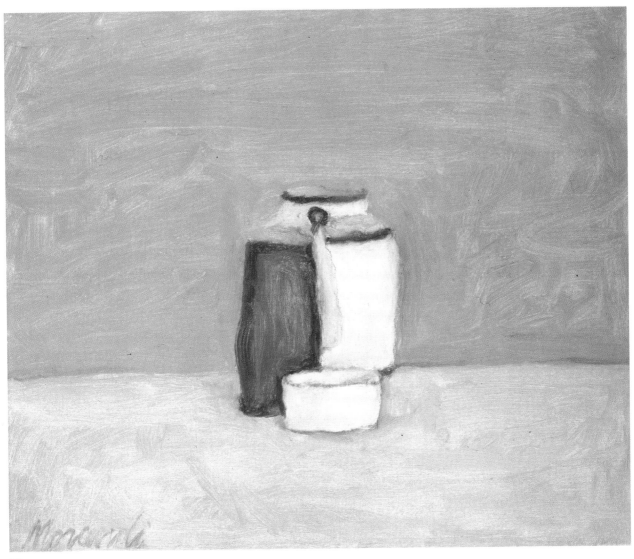

114

114.

Still Life, 1963.
Oil on canvas,
11 $^7/_8$ × 13 $^3/_4$ in. (30×35 cm).

you have traversed the streets and the arcades of this city and have understood that an apparently uniform reddish color can differentiate house from house and street from street."[40]

Such persistent dichotomies are at the heart of Morandi's work. As noted earlier, the American painter/critic, Sidney Tillim, described his Bolognese colleague as being "suspended between the speculative and the decorative" and as being "both ahead of his time and behind it." His observations are no doubt triggered by the uncanny way that Morandi's paintings seem to shift between radical dissection of things seen and fidelity to the particular. To these oppositions can be added Morandi's awareness of both likeness and unlikeness; his evident desire to respect actual appearances while filtering them through an individual sense of form and structure; his sense of connection with a past tradition; and his commitment to modernism. The critic Francesco Arcangeli, one of the most perceptive of Morandi's commentators, found this apparently equivocal attitude toward tradition to be characteristic of the artist, and saw a parallel in the work of Morandi's favorite poet, the nineteenth-century master of melancholy and disappointment, Giacomo Leopardi. Morandi's painting, Arcangeli observed in 1950, is related to that of the great innovators of the generations immediately preceding his own, from about 1870, in the same way that the poetry of Leopardi, who lived from 1798 to 1837, is related to the "widespread stirrings in European poetry after 1770."[41] Leopardi, one of the immortals of Italian literature, is a kind of pioneer modernist whose work, like Morandi's, taps enormous wells of feeling from an apparently circumscribed vantage point. The recurrent theme within Leopardi's poetry is the pain of having been denied, excluded, of having been forcibly turned into a distanced observer who scrutinizes his emotions with detachment, rather than a participant who simply experiences and lives within the sensation. The work of the painter, like that of the poet, Arcangeli notes, "at once has a share in the new and flatly denies it; it is a reply from what by now seems to be the almost timeless wisdom of a civilization, like the Italian, which the great Romantic movement seems to have pushed aside to the margins of the changing world."[42] Is this a conservative position? No. Both Morandi and Leopardi, he would argue, are no less modern because of their evident sense of continuity with the past.

Sometimes the correspondence between the work of the painter and his favorite poet seems uncanny. Morandi's etchings and paintings

115

115.

Landscape, 1963.
Oil on canvas,
15 ³/₄ × 17 ³/₄ in. (40 × 45 cm).

119

116

116.

Still Life, 1963.
Oil on canvas,
10×12 in. (25.5×30.5 cm).

of the uncompromising landscape of his native region, with their empty roads, their blank, windowless farmhouse walls, and obscuring expanses of foliage, seem to represent the opening lines of one of the most celebrated of Leopardi's *canti*, the brief, piercing reflection, *l'Infinito* ("The Infinite"):

> *Sempre caro mi fu quest'ermo colle,*
> *e questa siepe, che da tanta parte*
> *dell'ultimo orizzonte il guardo esclude.*
> *Ma sedendo e mirando, interminati*
> *spazi di là da quella, e sovrumani*
> *silenzi, e profondissima quiete*
> *io nel pensier mi fingo; ove per poco*
> *il cor non si spaura.*

It was always dear to me, this solitary hill, and this hedge that shuts off the gaze from so large a part of the uttermost horizon. But sitting and looking out, in thought I fashion for myself endless spaces beyond, more-than-human silences, and deepest quiet, where the heart is all but terrified.[43]

Similarly, the opening of a slightly later *canto*, *Il Sogno*, ("The Dream"), seems to evoke Morandi's views through the windows of the Via Fondazza, albeit in reverse:

> *Era il mattino, e tra le chiuse imposte*
> *per lo balcone insuava il sole*
> *nella mia cieca stanza il primo albore*

It was morning and through the closed shutters, the sun, the first light of day, crept furtively into my dark room by the balcony.

Even as a mature, internationally admired figure, Morandi made an effort to inform himself about what his younger contemporaries were doing. There is no complacency in even his last works, but instead, palpable evidence of his continuing curiousity about the possibilities of putting paint on canvas, about the expressive capabilities of touch and color. He seems never to have settled comfortably into a manner, however clear he was about his own direction and his particular preoccupations, but continued to test

himself against both his chosen ancestors and new challenges. Arcangeli, who was an admirer of the Abstract Expressionists, may have helped provide Morandi with information about current ideas. Whatever the source, Morandi was certainly aware of the movement, but was not convinced of its merits. A friend recalls his response to seeing a catalog of the work of Franz Kline. After carefully studying the reproductions of Kline's bold calligraphic black and white compositions of slashing, over-scaled brushmarks, Morandi is supposed to have remarked: "If I had been born twenty years later, I would find myself in the same state as today's painters. Something has ended; I wouldn't want to be young today."[44]

Yet Morandi's innate commitment to modernism, like his evident commitment to adventurousness in painting, was deeply ingrained. It is apparent even in his most seemingly conservative work. As we watch, pictures that seem unequivocally to be about particular places, objects, qualities of light, transubstantiate into resonant arrangements of densely brushed planes held in tension, and then shift back again into commentary on actual experience. The economy of Morandi's means, the self-imposed restrictions on his visual language, paradoxically coexistent with the dry opulence of his materials, make the best of his recondite, enigmatic pictures unforgettably intense; they seem to bear witness to a battle between the desire to remain faithful to perception and the will to alter, invent, restructure. The marginal dominance of pure, willful inventiveness places these fierce little pictures squarely in the realm of very radical painting.

Morandi himself perhaps said it best, in a statement that makes plain that his seemingly contradictory double allegiance to the literal and the invented was, in fact, not contradictory at all, but rather evidence of a deeply pragmatic sense of metaphysics. "I believe," he said, "that nothing can be more abstract, more unreal, than what we actually see. We know that all we can see of the objective world, as human beings, never really exists as we see and understand it. Matter exists, of course, but has no intrinsic meaning of its own, such as the meanings that we attach to it. We can know only that a cup is a cup, that a tree is a tree."[45]

Notes

1. Charles F. Stuckey, "Degas, artiste: sans cesse corriger et jamais achever," *Degas: le modelé et l'espace,* (Paris: Marais-Guilard Editions, 1984): 13.

2. Sidney Tillim, "Morandi: a critical note and a memoir," *Art Forum* (September 1967): 45.

3. Flavio Caroli, "Il nodo Longhi-Morandi," *Quaderni Morandiani No. 1: Morandi e il Suo Tempo,* incontri internazionale di studi su Giorgio Morandi, 16–17 November 1984, (Milano: Mazzotta, 1985): 90.

4. Marilena Pasquali, "Morandi e il dibattito artistico negli anni Trenta," *Quaderni Morandiani,* 114.

5. In *L'Italiano,* anno III, no. 16–17 (Bologna: 31 December 1928), reprinted in Lamberto Vitali, *Giorgio Morandi Pittore* (Milano: Edizioni del Milione, 1965): 49.

6. In "Momenti della pittura bolognese," *L'Archiginnasio,* XXX, no. 1–3 (Bologna, 1935), reprinted in Vitali, 51.

7. In "Morandi," *L'Italiano,* anno VII, no. 10 special issue (Bologna: March 1932) reprinted in Vitali, 51.

8. Tillim, "Morandi: a critical note," 43.

9. Giorgio Morandi, c. 1959, in Dore Ashton, ed. *Twentieth Century Artists on Art* (New York: Pantheon Books, 1985): 80.

10. Paolo Ingrao, "Ricordo di Giorgio Morandi," *Quaderni Morandiani,* 51.

11. Pier Giovanni Castagnoli and Marilena Pasquali, *Morandi nelle raccolte private bolognesi* (Bologna: Edizione AGE, 1989): 10–11.

12. Roberto Longhi, *Catalogo della mostra di dipinti di Giorgio Morandi* (Firenze: Galleria del Fiore, April 1945), reprinted in Vitali, 57.

13. Letter to Luigi Magnani, 10 April 1956. Luigi Magnani, *Il Mio Morandi* (Torino: Einaudi, 1982) 93.

14. For a detailed chronology see the catalog of the Museo Morandi, Bologna (Milano e Firenze: Edizione Charta, 1993).

15. Pasquali, "Morandi e il dibattito," 119.

16. "Morandi: a critical note," 45.

17. John Rewald, in catalog of Morandi exhibition, Albert Loeb and Krugier Gallery, May 1967, quoted by Tillim, ibid.

18. Giuseppe Raimondi, *Anni con Giorgio Morandi* (Milano: Arnaldo Mondadori Editore, 1970): 23.

19. Castagnoli and Pasquali, *Morandi nelle raccolte private bolognesi,* 10.

20. Ingrao, "Ricordo di Giorgio Morandi,".47.

21. Longanesi in Vitali, 48.

22. Ibid.

23. Rewald, quoted in Tillim, "Morandi: a critical note," 46.

24. Magnani, *Il Mio Morandi,* 6–7.

25. Letter to Luigi Magnanii, 18 December 1954. Magnani, *Il Mio Morandi,* 81.

26. Raimondi, *Anni con Giorgio Morandi,* 190, 193.

27. Ibid., 185–201, passim.

28. Ibid., 49.

29. Ibid., 50–51.

30. Ibid., 29.

31. Franco Solmi, "Giorgio Morandi: gli anni della formazione," *Quaderni Morandiani,* 27.

32. Eugenio Riccòmini, "Morandi e i congeneri," *Quaderni Morandiani,* 15.

33. Raimondi, *Anni con Giorgio Morandi,* 77, 99.

34. Joan M. Lukach, "Giorgio Morandi, 20th Century Modern: Toward a Better Understanding of his Art, 1910–1943," *Giorgio Morandi,* exhibition catalog (Des Moines, Iowa: Des Moines Art Center, 1981): 21.

35. For a detailed discussion of the artists of the Metaphysical School in relation to Morandi, see Lukach, "Giorgio Morandi, 20th Century Modern," passim.

36. In conversation with Stephen Haller, Grizzana studio, summer, 1964.

37. Paolo Fossati, "Giorgio Morandi e gli anni di *Valori Plastici,*" *Quaderni Morandiani,* 37.

38. Lukach, "Giorgio Morandi, 20th Century Modern," 27.

39. Fossati, "Giorgio Morandi e gli anni di *Valori Plastici,*" 38.

40. Umberto Eco, address delivered at the opening of the Museo Morandi, Bologna, October 1993; text distributed by the museum.

41. Francesco Arcangeli, *12 Opere di Giorgio Morandi* (Milano: Edizione del Milione, 1950), reprinted in Vitali, 60.

42. Ibid.

43. Prose translation from George Kay, ed. *The Penguin Book of Italian Verse* (London: Penguin Books, 1965).

44. Ingrao, "Ricordo di Giorgio Morandi," 49.

45. Ashton, *Twentieth-Century Artists on Art,* 80.

Selected Bibliography

Ashton, Dore, ed. *Twentieth Century Artists on Art*. New York: Pantheon Books, 1985.

Brandi, Cesare. *Morandi*. Roma: Editori Riuniti, 1990.

Castagnoli, Pier Giovanni and Pasquali, Marilena. *Morandi nelle raccolte private bolognesi*. Bologna: Edizioni AGE, 1989.

Des Moines Art Center. *Giorgio Morandi*, exhibition catalogue. Des Moines, Iowa: Des Moines Art Center, 1981.

Garberi, Mercedes. *Giorgio Morandi*, exhibition catalogue. Kamakura, Japan: The Museum of Modern Art, Kamakura, 1989.

Kay, George, ed. *The Penguin Book of Italian Verse*. London: Penguin Books, 1965.

Leopardi, Giuseppe. *Canti*. Milano: Edizioni Garzanti, 1991.

Magnani, Luigi. *Il Mio Morandi*. Torino: Giulio Einaudi, editore, 1982.

Pasquali, Marilena. *Museo Morandi, Bologna, il catalogo*. Milano, Firenze: Edizioni Charta and Bologna: Museo Morandi, 1993. (Contains detailed chronology, exhibition history, and complete bibliography.)

Pasquali, Marilena. *Giorgio Morandi: L'immagine dell'assenza*. Milano: Edizioni Charta and Bologna: Museo Morandi, 1994.

Quaderni Morandiani No.1, incontro internazionale di studi su Giorgio Morandi. "Morandi e il Suo Tempo." Milano: Mazzotta, 1985.

Raimondi, Giuseppe. *Anni con Giorgio Morandi*. Milano: Arnaldo Mondadori, editore, 1970

Tillim, Sidney. "Morandi: a critical note and a memoir," *Art Forum* (September 1967):42-46.

Vancouver Art Gallery. *Giorgio Morandi*, exhibition catalogue. Vancouver, Canada: Vancouver Art Gallery, 1977.

Vitali, Lamberto. *Giorgio Morandi - Pittore*. Milano: Edizioni del Milione, 1965.

List of Illustrations

37. *Landscape*, 1940.
Oil on canvas,
13 3/4 × 19 3/4 in. (35 × 50 cm).
Boschi-Di Stefano Collection,
Museo d'Arte Contemporanea,
Milano.

38. *Still Life*, 1940.
Oil on canvas,
18 7/8 × 21 1/8 in. (47 × 52.8 cm).
Staatliche Museen zu Berlin -
Prussischer Kulturbesitz
Nationalgalerie
Photo: Jörg P. Anders, Berlin, 1969

39. *Landscape*, 1940.
Oil on canvas,
18 7/8 × 20 7/8 in. (48 × 53 cm).
Boschi-Di Stefano Collection,
Museo d'Arte Contemporanea,
Milano.

40. Objects in Morandi's studio.
Photo: Duane Michals.
Courtesy Stephen Haller Gallery,
New York.

41. *Landscape*, 1941.
Oil on canvas,
14 5/8 × 15 3/4 in. (37 × 40 cm).
Boschi-Di Stefano Collection,
Museo d'Arte Contemporanea,
Milano.

42. *Still Life*, 1942.
Oil on canvas,
11 7/8 × 15 3/4 in. (30 × 40 cm).
The Art Gallery of Western
Australia.

43. *Still Life*, 1942.
Oil on canvas,
15 × 16 1/2 in. (38 × 42 cm).
Fondazione Magnani Rocca,
Mamiano di Traversetolo (Parma).

44. *Still Life*, 1942.
Oil on canvas,
18 1/2 × 16 in. (47 × 40.5 cm).
Fondazione Magnani Rocca,
Mamiano di Traversetolo (Parma).

45. *Still Life*, 1943.
Oil on canvas,
9 7/8 × 15 3/4 in. (25 × 40 cm).
Boschi-Di Stefano Collection,
Museo d'Arte Contemporanea,
Milano.

46. *Landscape*, 1943.
Oil on canvas,
12 7/8 × 15 in. (32.8 × 38 cm).
Museo Morandi, Bologna.

47. *Still Life*, 1943.
Oil on canvas,
9 × 13 7/8 in. (22.8 × 35.3 cm).
Hirshhorn Museum and Sculpture
Garden, Smithsonian Institution,
Washington, D.C.
Gift of the Marion L. Ring Estate,
1987.

48. *Still Life*, 1944.
Oil on canvas,
11 7/8 × 20 7/8 in. (30 × 53 cm).
Collections Mnam/Cci/Centre
Georges Pompidou, Paris.

49. *Landscape*, 1944.
Oil on canvas,
12 1/8 × 20 7/8 in. (31 × 53 cm).
Civico Museo Revoltella, Trieste.

50. *Landscape*, 1944.
Oil on canvas,
19 1/8 × 17 3/4 in. (48.5 × 45 cm).
Galleria Nazionale d'Arte Moderna,
Roma.

51. *Still Life*, 1944.
Graphite on paper,
9 × 12 1/8 in. (23 × 30.7 cm).
Courtesy Paolo Baldacci Gallery.

52. *Still Life*, 1946.
Oil on canvas,
9 7/8 × 17 3/4 in. (25 × 45 cm).
Tompkins Collection.
Courtesy of Museum of Fine Arts,
Boston.

53. *Still Life*, 1946.
Oil on canvas,
11 3/4 × 18 3/4 in. (29.9 × 47.7 cm).
Galleria Nazionale d'Arte Moderna,
Roma.

54. *Still Life*, 1947-48.
Oil on canvas,
12 × 17 3/4 in. (30.5 × 43 cm).
Museum Boymans-van Beuningen,
Rotterdam.

55. *Large Circular Still Life with Bottle
and Three Objects*, 1946.
Etching on copper,
12 3/4 × 10 1/8 in. (32.5 × 25.8 cm).
(c) 1961 The Dayton Art Institute.
Museum purchase with funds
provided by the Junior League of
Dayton, Ohio, Inc.

56. *Still Life*, 1946.
Oil on canvas,
14 3/4 × 15 3/4 in. (37.5 × 40 cm).
Tate Gallery, London.

57. *Still Life*, 1947.
Graphite on paper,
9 1/2 × 11 7/8 in. (24 × 30 cm).
Museo Morandi, Bologna.

58. *Still Life*, 1948.
Graphite on paper,
4 1/8 × 5 3/4 in. (10.3 × 14.5 cm).
Private collection.
Courtesy Stephen Haller Gallery,
New York.

59. *Flowers*, 1947.
Oil on canvas,
13 × 11 5/8 in. (33 × 29.5 cm).
Courtesy Paolo Baldacci Gallery.

60. *Still Life*, 1948.
Oil on canvas,
14 3/4 × 17 3/4 in. (35.5 × 30.5 cm).
Museo d'Arte Contemporanea,
Palazzo Reale, Milano.

61. *Still Life*, 1948.
Oil on canvas,
10 1/4 × 15 1/8 in. (26 × 38.5 cm).
Courtesy Paolo Baldacci Gallery,
New York.

62. *Still Life*, 1948.
Oil on canvas,
14 1/4 × 14 1/4 in. (36 × 36 cm).
Courtesy Paolo Baldacci Gallery,
New York.

63. *Still Life*, 1948.
Oil on canvas,
13 3/4 × 15 3/4 in. (35 × 40 cm).
Boschi-Di Stefano Collection,
Museo d'Arte Contemporanea,
Milano.

64. *Still Life*, 1948.
Oil on canvas,
14 1/4 × 16 1/8 in. (36 × 41 cm).
Museo Morandi, Bologna.

65. *Still Life*, 1948.
Oil on canvas,
12 × 14 in. (30.5 × 35.5 cm).
Grassi Collection,
Galleria d'Arte Contemporanea,
Villa Reale, Milano.

66. *Still Life*, 1948.
Oil on canvas,
10 1/4 × 15 3/4 in. (26 × 40 cm).
Fondazione Magnani Rocca,
Mamiano di Traversetolo (Parma).

67. *Still Life*, 1949.
Oil on canvas,
11 7/8 × 15 3/4 in. (30 × 40 cm).
Museo Morandi, Bologna.

68. *Still Life*, 1949.
Oil on canvas,
14 1/4 × 17 7/8 in. (36 × 45.2 cm).
Museo Morandi, Bologna.

69. *Still Life*, 1949.
Oil on canvas,
14 × 19 3/4 in. (35.5 × 50 cm).
Jucker Collection.
Museo d'Arte Contemporanea,
Palazzo Reale, Milano.

70. *Still Life*, 1951.
Oil on canvas,
8 7/8 × 19 3/4 in. (22.5 × 50 cm).
Kunstsammlung Nordrhein-
Westfalen, Düsseldorf.

71. *Still Life*, 1951.
Oil on canvas,
13 × 16 7/8 in. (33 × 43 cm).
Tel Aviv Museum of Art.

72. *Still Life*, 1951.
Oil on canvas,
14 1/4 × 15 3/4 in. (36 × 40 cm).
Museo Morandi, Bologna.

73. *Still Life*, 1951.
Oil on canvas,
15 3/8 × 17 3/4 in. (39 × 45 cm).
Museo Morandi, Bologna.

74. *Still Life*, 1952.
Oil on canvas,
14 × 17 7/8 in. (35.5 × 45.5 cm).
Courtesy Paolo Baldacci Gallery,
New York

75. *Still Life*, 1952.
Oil on canvas,
12 5/8 × 18 7/8 in. (32 × 48 cm).
Museo Morandi, Bologna.

76. *Still Life*, 1952.
Oil on canvas,
14×17⅞ in. (35.5.×45.5 cm).
Fondazione Magnani Rocca,
Mamiano di Traversetolo (Parma).

77. *Still Life*, 1952.
Graphite on paper,
9×12⅝ in. (22.8×32 cm).
Museo Morandi, Bologna.

78. *Bottles and a Pitcher*, 1952.
Graphite on paper,
9×10½ in. (22.5×26.5 cm).
Sheldon Memorial Art Gallery,
University of Nebraska, Lincoln,
Nebraska.

79. *Still Life*, 1953.
Oil on canvas,
7⅞×15¾ in. (20×40 cm).
The Phillips Collection, Washington,
D.C.

80. *Still Life*, 1953.
Oil on canvas,
11½×14⅝ in. (29×37 cm).
The Saint Louis Art Museum

81. *Still Life*, 1953.
Oil on canvas,
7⅞×15¾ in. (20×45 cm).
Private collection, New York.

82. *Still Life*, 1953.
Oil on canvas,
13×17⅞ in. (33×45.5 cm).
Sara Hilden Foundation, Sara
Hilden Art Museum
Tampere, Finland.

83. *Still Life*, 1954.
Oil on canvas,
11⅞×13¾ in. (30×35 cm).
Private collection, Firenze.

84. *Still Life*, 1954.
Oil on canvas,
13¼×18¼ in. (33.5×46.3 cm).
Smith College Museum of Art,
Northampton, Massachusetts,
Purchased 1954.

85. *Courtyard at Via Fondazza*, 1954.
Oil on canvas,
22×22 in. (56×56 cm).
Museo Morandi, Bologna.

86. *Courtyard at Via Fondazza*, 1954.
Oil on canvas,
22¼×17¼ in. (55.5×45.5 cm).
Museum Boymans-van Beuningen,
Rotterdam.

87. *Courtyard at Via Fondazza*, 1954.
Oil on canvas,
19¼×21¼ in. (49×54 cm).
Fondazione Magnani Rocca,
Mamiano dio Traversetolo (Parma).

88. *Still Life*, 1954.
Graphite on paper,
6½×9¼ in. (16.3×23.5 cm).
Courtesy Paolo Baldacci Gallery.

89. *Still Life*, 1955.
Oil on canvas,
9½×13⅜ in. (24×34 cm).
Stedelijk Museum, Amsterdam.

90. *Still Life*, 1955.
Oil on canvas,
11⅞×15¾ in. (30×40 cm).
Mr. and Mrs. Paul Mellon Collection,
Upperville, Virginia.

91. *Still Life*, 1956.
Oil on canvas,
9⅞×15 in. (25×38 cm).
Mr. and Mrs. Paul Mellon Collection,
Upperville, Virginia.

92. *Still Life*, 1956.
Oil on canvas,
14⅛×13⅞ in. (35.8×35.2 cm).
Museo Morandi, Bologna.

93. *Still Life*, 1956.
Oil on canvas,
11⅞×17¾ in. (30×45 cm).
Museo Morandi, Bologna.

94. *Still Life*, 1957.
Oil on canvas,
10½×15¾ in. (27×40 cm).
Hamburger Kunsthalle, Hamburg.
Photo: Elke Waldford.

95. *Still Life*, 1957.
Oil on canvas,
9⅞×15¾ in. (25×40 cm).
University of Iowa Museum of Art.

96. *Still Life*, 1957.
Oil on canvas,
13¾×17¾ in. (35×45 cm).
Pinacoteca Vaticana.

97. *Still Life*, 1957.
Oil on canvas,
9⅞×13¾ in. (25×35 cm).
Private collection.
Courtesy Paolo Baldacci Gallery,
New York.

98. *Still Life*, 1957.
Graphite on paper,
6⅛×9 in. (15.7×23 cm).
Private collection, New York.
Courtesy Stephen Haller Gallery,
New York.
Photo: Bayat Keerl.

99. *Still Life*, 1958.
Graphite on paper,
6½×9½ in. (16.5×24 cm).
Museo Morandi, Bologna.

100. *Courtyard at Via Fondazza*, 1958.
Oil on canvas,
12×16 in. (30.6×40.5 cm).
Museo Morandi, Bologna.

101. *Courtyard at Via Fondazza*, 1958.
Oil on canvas,
17⅞×19¾ in. (45.5×50 cm).
Museo Morandi, Bologna.

102. *Still Life*, 1958.
Oil on canvas,
9⅞×11⅞ in. (25×30 cm).
Staatsgalerie moderner Kunst
München.
Photo: Arthothek.

103. *Still Life*, 1959.
Oil on canvas,
11⅞×14 in. (30×35 cm).
Virginia Museum of Fine Arts,
Richmond, VA.
Mr. and Mrs. Paul Mellon Collection,
Upperville, Virginia.

104. *Still Life*, 1960.
Watercolor,
9⅞×13¾ in. (25×34 cm).
Private collection, New York.
Courtesy Stephen Haller Gallery,
New York.
Photo: Bayat Keerl.

105. *Still Life*, 1960-64.
Watercolor,
5⅜×10⅛ in. (13.5×25.8 cm).
In Memory of Paul Rewald.
Fogg art Museum,
Harvard University.

106. *Still Life*, 1960.
Graphite on paper,
6⅛×8⅝ in. (15.7×21.8 cm).
Courtesy Paolo Baldacci Gallery,
New York.

107. *Landscape*, 1962.
Oil on canvas,
11⅞×13¾ in. (30×35 cm).
Museo Morandi, Bologna.

108. *Still Life*, 1960.
Oil on canvas,
12×16 in. (30.5×40.5 cm).
Museo Morandi, Bologna.

109. *Still Life*, 1961.
Oil on canvas,
9⅞×11⅞ in. (25×30 cm).
Museo Morandi, Bologna.

110. *Landscape*, 1962.
Graphite on paper,
9¼×12⅜ in. (23×31 cm).
Collection Fondazione Antonio
Mazzotta, Milano.

111. *Landscape*, 1962.
Oil on canvas,
10×12⅜ in. (25.5×31 cm).
Museo Morandi, Bologna.

112. *Still Life*, 1962.
Oil on canvas,
13¾×13¾ in. (35×35 cm).
Museo Morandi, Bologna.

113. *Still Life*, 1962.
Oil on canvas,
11⅞×11⅞ in. (30×30 cm).
Scottish National Gallery of Modern
Art, Edimburgh.

114. *Still Life*, 1963.
Oil on canvas,
11⅞×13¾ in. (30×35 cm).
Museo Morandi, Bologna.

115. *Landscape*, 1963.
Oil on canvas,
15¾×17¾ in. (40×45 cm).
Museo Morandi, Bologna.

116. *Still Life*, 1963.
Oil on canvas,
10×12 in. (25.5×30.5 cm).
Museo Morandi, Bologna.